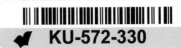
PAINTING DOG PORTRAITS
IN ACRYLICS

CREATING PAINTINGS WITH CHARACTER AND LIFE

DAVE WHITE

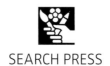

SEARCH PRESS

FOREWORD

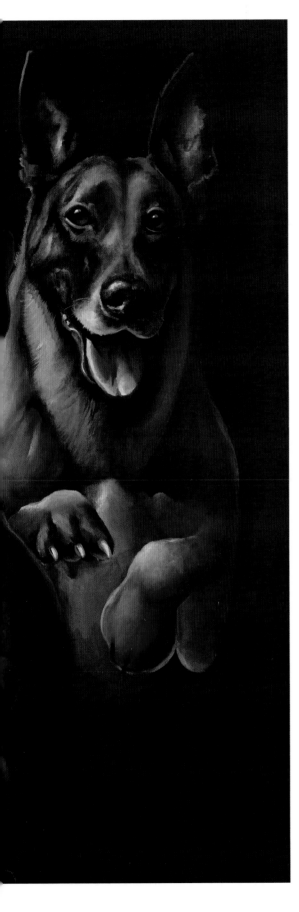

I remember walking around Crufts, as I do every year, and stumbling across a stand with the most awe-inspiring paintings displayed. My gaze fixed on the paintings of people's dogs with such detail I could almost read their characters. Finally, I managed to pull myself away, only to find myself drifting back a third, fourth and fifth time in the hope of speaking with the artist. Little did I expect Dave to ask me to write the foreword for his book that very same day.

I was excited at the prospect, not because I have the artistic ability of a blind walrus (although I'm very aware I do) but more because Dave had agreed to paint our dogs and had explained that this was going to be a journey, one which Jo-Rosie and I would very much be part of.

Dave visited us and met our troop of dogs, who all felt instantly at ease with him. It was a joy to watch them appear step by step on canvas. The guidance we received throughout the project was second to none, and if it wasn't for the revealing nature of the text in the coming pages I would have presumed it a simple task, not sparing a thought for the composition, the pros and cons of various methods or even the mathematics involved in such an undertaking.

This book is everything you need to be the artist you aspire to be, and I know that if someone had written a book as comprehensive as this for training dogs, I would have been a better trainer quicker!

Now it's your chance to be guided through a journey while Dave shares his wealth of experience which will bring you far-reaching benefits and rich rewards.

•

NANDO BROWN AND JO-ROSIE HAFFENDEN, dog training experts and presenters of Channel 4's *Rescue Dog to Super Dog* and ITV's *Teach My Pet To Do That*.

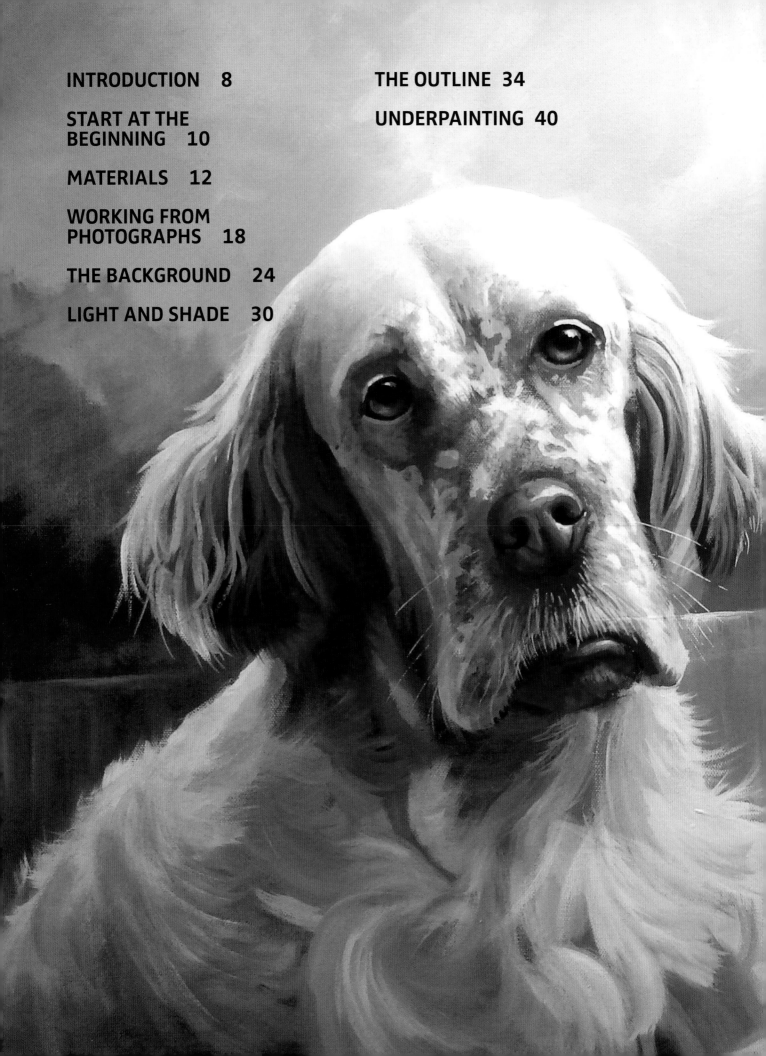

CONTENTS

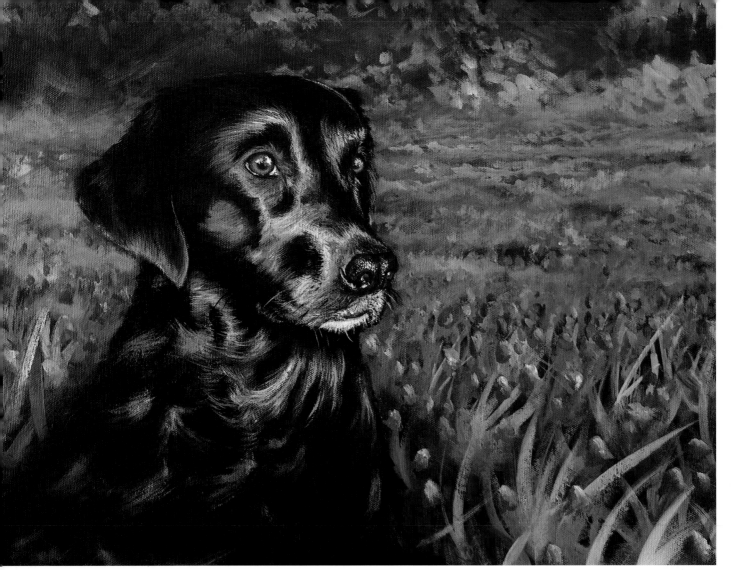

INTRODUCTION

SAFFIE – LABRADOR
61 x 45.7cm (24 x 18in)

This was my first commissioned dog portrait, painted in memory of Saffie, who had passed away.

This book is for all those who want to paint their pet – or someone else's – and don't know where to start. It will teach you how to set your painting apart from all the rest by painting more three-dimensionally. It expounds the techniques of acrylics and all the benefits they bring. It is also for those who already paint dogs but want to improve their techniques. There is advice at the end for dog portrait artists who want to turn their creative gift into a business.

I started my painting career on 27th April 2004, having worked in finance for more than thirty years. On that day, my employer offered me redundancy, giving me two weeks to consider it. During that time, I painted two landscapes in oil and the comments I received encouraged me to start to paint professionally. However, if you had said at that time that I would end up painting living things, I would have laughed. My art teacher had written: 'his art will not amount to anything', so I had switched focus to Business Studies and hadn't touched a brush for thirty years.

To begin with, I painted golf scenes. A friend got a hole in one and said, 'Dave, paint the hole!' A few days later he rang me, upset. Saffie, his faithful Labrador of sixteen years had passed away, and instead of the golf painting, he asked me to paint her portrait. I'd never painted a dog in my life. To add to the challenge, he only had two photographs of her: one black and white and one in colour, but with the dog running away from the camera.

It took me a week to make the painting look like a dog and another to make it look like his dog. His wife saw the first draft, as the painting was to be for his birthday. She burst into tears, saying, 'That's our Saffie.' She asked me to put Saffie in a bluebell wood, the scene of her last walk. This taught me that it is harder to paint the background after the main subject than before.

I then painted our dog, the neighbour's dog and a friend's dog, and showed them as part of my monthly exhibition at a hotel where I was Artist-in-residence. One visitor after another asked me to paint their dogs, past and present, and my career took off.

To create a recognisable likeness is one of the most difficult but rewarding things to do in art. However, if you don't feel that you want to reach out and touch the nose or the fur, or if the eyes don't follow you when you stand back, the job is not done. So this book will teach you how to make your paintings look three-dimensional and feel that the image is alive.

My medium of choice is acrylics: it is highly versatile, dries quickly and is user-friendly. This book will help all those who wrestle with acrylics to optimize their properties. If you are not interested in acrylics, you will still learn to develop your pet portrait ability.

Although this book features dogs, all the techniques apply to painting any pet, so if you are a cat, cow or even a llama lover, read on!

Dogs are part of our families; they work for us, give us company and unselfishly love us, but their lifespans are on average seven times shorter than ours. It is natural, therefore, that many people want to capture the image of their beloved companion and display it at home.

I know that many artists would love to make a living from their creative gift, so I have provided guidance to help.

Whether you are young or old, beginner or professional, you will find something to help you on your pet portrait journey in this book. If you don't paint yourself but have a child or grandchild you wish to encourage, this is the gift for them.

The book should be a reference that you will continually go to, so that every page becomes dog-eared from use. Do each project three times. After that, offer to paint someone's pet for them – it is by doing this that you will really learn.

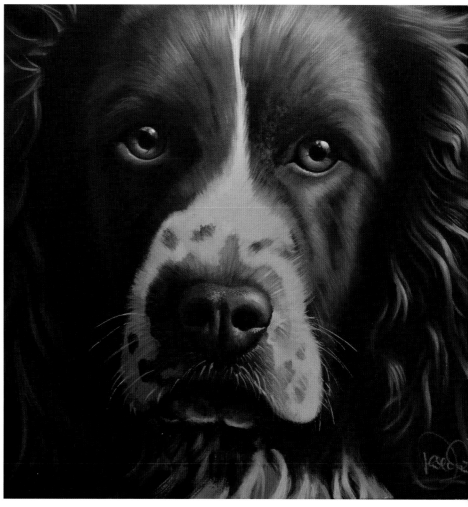

SPRINGER SPANIEL
61 x 61cm (24 x 24in)

This is a composite painting combining several different portraits of Springer Spaniels. Since most of my paintings are on the dog owners' walls, it pays to have one like this to show to prospective customers.

START AT THE BEGINNING

All artists want to get on with the painting. You have an image you want to capture, but when you get to that blank canvas, you wonder what to do first. This is because so much about what you are trying to achieve is unknown. I suggest you ask the following question: Where is the painting going to hang? The answer will establish a number of things which might mean you have to start your thought processes again.

When I do any commission, I have a list of questions for my commissioner, and you might find these useful too:

- *In which room will the painting hang?*

If it's a lounge, you might want a 'wow' from all your visitors, while a bedroom might require a more reflective mood.

- *On which wall will it hang? Is it a wall you face or a passing place?*

If it is a passing place, avoid a thick block canvas which could be knocked.

- *What are the proportions and shape of the wall?*

If the wall is at the end of a long room, you might want a square canvas; if it is wide, you need a more elongated support. If a standard support is not right, you can have a bespoke one made.

- *Where is the south-facing window relative to that wall?*

This is where the natural light comes from, and the room is normally set up to make the most of this, which affects where the TV is and where people sit. The answer to this question tells you which side of the dog's face to light.

- *What is the room's predominant colour scheme?*

This will define whether the background colour of your painting is cool or warm. Use a sympathetic colour, such as light blue background against a dark blue wall, or a complementary, such as red on a green wall.

- *Where do people sit relative to the wall?*

If people normally sit to the right of the wall, have the dog looking from left to right towards them, rather than out of the window. Where people sit will also tell you if you should use gloss or matt varnish (see page 17) for the final painting: if the final hung picture is likely to be highly reflective, you will have to use matt varnish or matt finish paint.

- *Is there a heat source below where the painting will hang?*

If a radiator is directly below the painting, you might need to avoid warping by using an aluminium rather than a wooden stretcher (this is the structure the canvas is stretched over and attached to). You might also choose linen rather than canvas, and a block rather than a narrow stretcher.

- *Are there other paintings in the room?*

If other paintings are framed, an unframed dog portrait will look wrong. You might need to use a smaller canvas to allow for a frame.

- *Is it a modern room or more traditional?*

A modern room would suit an unframed block canvas while a framed painting would look better in a traditional setting.

What happens, you might say, if you don't know where the painting will hang, or if there are a number of alternative walls which might be chosen, especially if the painting is to be a surprise?

For an undefined future setting, you could consider the dog itself and what might suit its image best in relation to the background colour, the best side of the face and the canvas size. You can then allow the customer to choose a wall that suits the final painting.

If a number of alternative walls might be chosen, you could assess whether there is a common light source, canvas size and background colour which would suit the majority of the walls.

ARCHIE AND ROSIE –
NEWFOUNDLANDS
91.4 x 61cm (36 x 24in)

This painting hangs in a conservatory, where the light naturally comes from above and mainly the right.

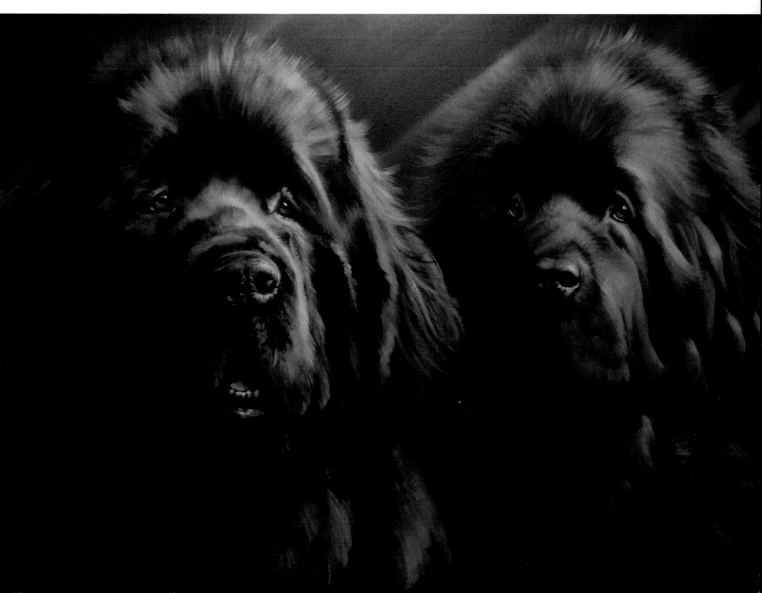

MATERIALS

SUPPORTS

Acrylics can be used on canvas, paper, wood, boards or anything the paint will stick to. Acrylic paint will not stick to an oil-based surface. Daler boards are often oil-based but canvas boards can be used for oils or acrylics. Once you have painted acrylics on a support and the paint has dried, it is now an acrylic surface which is non-absorbent and will stay wet longer.

Block canvases in fine-grain linen and medium-grade canvas and a gummed block of Not surface 300gsm (140lb) watercolour practice paper.

PAPER

The cheapest support is paper, and I suggest watercolour practice paper. If you don't want to stretch the paper, the most efficient purchase is a block of watercolour practice paper which usually contains about twelve sheets, gummed together round the sides. This stops the paper cockling or curling while you are painting. I tend to avoid specialist acrylic paper, which is a canvas replica weave embedded into a paper support. It is more expense for little benefit and the sheets often don't come in block, so tend to curl unless they are taped to a wooden board.

CANVAS

The choice of canvases available nowadays can be mind-blowing! With some suppliers you can build your own canvas or buy ready-made stretched canvases or canvas stretched on boards (usually cardboard). There are oil-primed canvases exclusively for oil painting, canvases for watercolour and even ones for inkjet printers. There are also universally primed canvases for any paint. All of these can come with a different finish: rough, smooth or something in between. I prefer a smooth finish because it can be difficult to paint fine details on a rough surface.

If you know you are going to be giving or selling the finished painting or putting it on your own wall, it is best to use a stretched canvas. Most suppliers provide canvases gesso-primed and stretched on wooden stretchers. My only caveat to wooden stretchers is that if the canvas is to be 101.6 x 76.2cm (40 x 30in) or larger, it's worthwhile using a block canvas 3.8cm (1½in) or more thick to avoid warping. This applies only if you are not going to frame the painting afterwards. A frame will stabilize a canvas, but you don't have to frame an acrylic painting as you do with most media for dust and damage protection, because acrylic paint is flexible when dry and, to a degree, self-protecting. Warping can occur in some stretched canvases if the painting is in a warm place, such as over a radiator. In this case you can use a canvas with aluminium stretchers, which I use for my major, multi-dog paintings over 91.4 x 61cm (36 x 24in). They are more expensive and much heavier, but are solid supports which will not warp.

For all the project paintings in this book, however, I suggest you use either a watercolour practice paper block or canvas boards of the sizes given. These are the least expensive and are readily available.

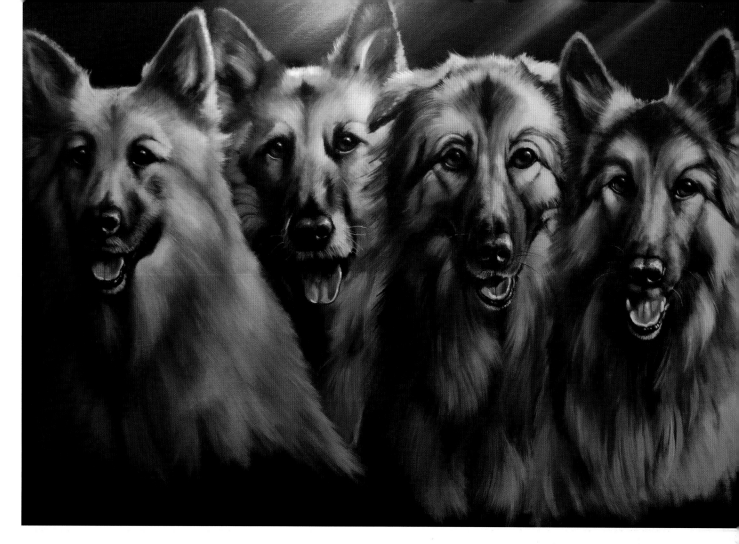

MEG, RIKA, KIA AND GYPSY – GERMAN SHEPHERDS
140 x 101.6cm (55 x 40in)

A huge wall demanded a bespoke size canvas so that I could paint these dogs life size.

PALETTES

Many artists complain that acrylic paints dry too quickly. This is because they are bound with polymer resin, which dries in contact with oxygen. If you can deprive the paint of oxygen, it will dry more slowly. This is why I recycle clear plastic dessert pots to use as palettes. When I am not using one of these dessert pot palettes, I turn it upside down to keep the air out and the paint stays wet for at least twenty-four hours, if not longer. Since the dessert pot palette is oil-based, when the paint does eventually dry you can peel it off, leaving the palette clean for your next painting session.

Try to find clear plastic pots if you can, as this allows you to see when the mix of water and paint has become transparent.

I vary the number of palettes I use for a painting: for instance, I might keep all my brown mixes in one palette or I might put all my tints in one and shades in another.

13

ACRYLIC PAINTS

First, let's look at the properties of the acrylic paints made by some of the major suppliers. The table below shows suppliers' descriptions of these properties. It illustrates the differences between the ranges in paints labelled as the same colour. I have used generic names for colours, but some suppliers use their own equivalents. Paint ranges change, and this is just a snapshot; always consult the manufacturers' current descriptions.

If a painting is going to hang in a place where light will reflect on it, consider using a matt rather than a gloss or satin finish paint. One minor disadvantage with a gloss finish is that you can't always see when the paint has dried, so you need to rely on touch to test it. You might also end up with a painting in which you can't see the subject because of a reflection. The table shows which paints have which finish. You could use a matt finish for the background and a gloss for the subject.

The transparency differs in the various manufacturers' colours, from opaque through semi-opaque to transparent. Opaques tend to be stronger or denser and are excellent for underpainting, while transparents appear slightly weaker, but produce gloriously colourful depth when used as glazes over an underpainting. If you mix opaques and transparents, the opaques will tend to dominate, and to get the colour mix you want, you will require more volume of transparent paint.

The brand you need depends on what you want the paint to do and what suits your style. I used Daler Rowney System 3 for colours 1–8 and Winsor & Newton Professional burnt umber and burnt sienna for glazing. In the chapter on Noses (page 52) I mention using Venetian red for rare red-nosed dogs, such as some Springers, but you don't need this colour for the projects. Depending on the backgrounds you wish to create, there will be additional colours: I used copper, pale and rich gold and Hooker's green.

If you already have some of the colours in the table, use those first; if not, purchase at least an opaque or semi-opaque of each of the colours 1–5 (titanium white to burnt sienna), plus a transparent or semi-transparent of colours 4–7 (burnt umber to cadmium red deep). You can't buy this selection as a set, so you will need to pick and choose.

COLOUR:	1. TITANIUM WHITE	2. MARS BLACK	3. YELLOW OCHRE	4. BURNT UMBER	
SUPPLIER:					
Daler Rowney System 3	O	O	S/T	S/T	
Daler Rowney Cryla Artists' Acrylics	O	O	S/O	S/O	
Winsor & Newton Professional Acrylics	O	O	S/T	T	
Winsor & Newton Galleria	O	O	O	O	
Atelier	O	O	O	S/T	
Schminke	S/T	O	S/T	S/O	
SAA	S/O	T	S/T	O	
Jackson's	O	S/O	O	S/T	

Key: O = opaque; T = transparent; S/T = semi-transparent; S/O = semi-opaque

	5. BURNT SIENNA	6. FRENCH ULTRAMARINE	7. CADMIUM RED DEEP	GLOSS (G)/SATIN (S)/ MATT (M)
	T	S/T	S/T	M
	S/O	S/T	O	S
	T	T	T	G
	T	T	T	S
	S/T	S/T	T	S
	S/O	O	O	S/G and S/M
	O	S/T	T	S/M
	S/O	O	O	M

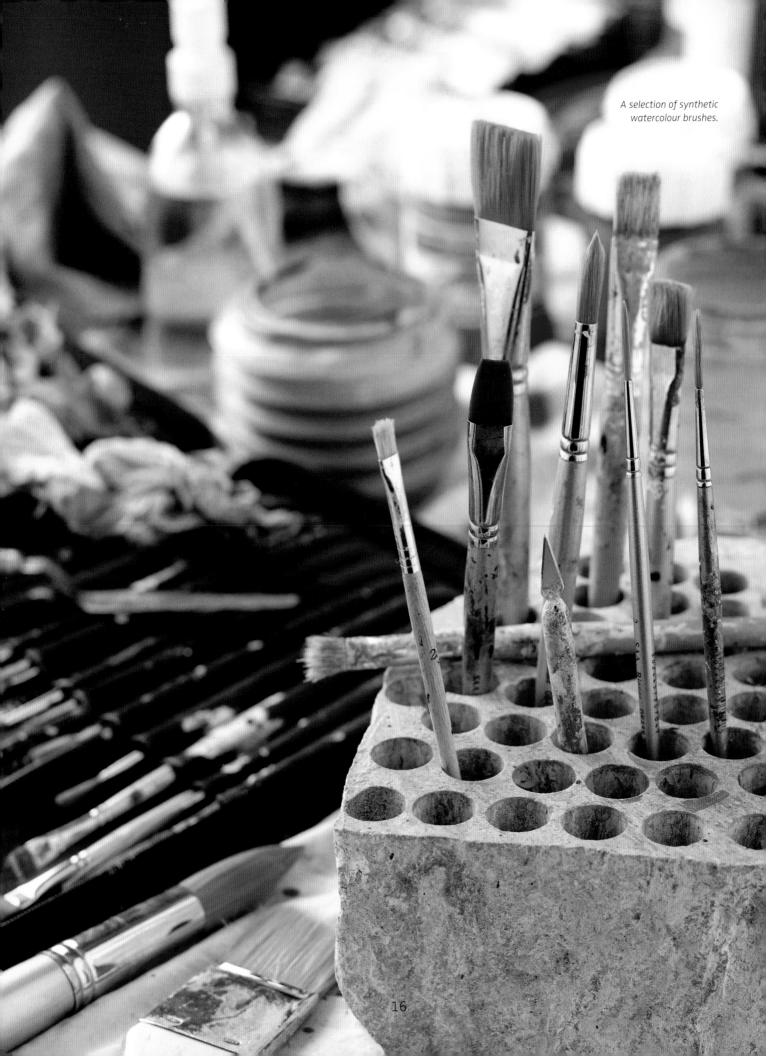

A selection of synthetic
watercolour brushes.

BRUSHES

An acrylic brush is usually made of a bristle and tends to have a stiff, hard feel so that it can carve into a coat of paint, revealing what is underneath. I prefer to use a synthetic watercolour brush, which is made of hair and holds more water and paint, resulting in a smoother, softer brushstroke. Genuine hair watercolour brushes are too soft to apply a heavier paint like acrylics.

The synthetic brush shapes I use are round, flat and long-haired riggers in various numbered sizes. I also use specialist brushes which help to create the illusion of fur. A rake is a brush made of two types of synthetic hair. The central line of hair is firmer and separated to produce fine lines of paint. This is supported by a surround of synthetic hair, which holds more water and paint and feeds the central line, allowing the brushstroke to go on for longer before the paint and water run out.

Rakes come in various widths: I recommend a 13mm (½in) rake for most images on canvases of 50.8 x 40.6cm (20 x 16in) or even 61 x 45.7cm (24 x 18in). Rakes cost a little more than normal synthetic hair brushes, but it is worth investing in a quality brush which lasts longer. Here is my selection of Da Vinci rakes by Jackson's.

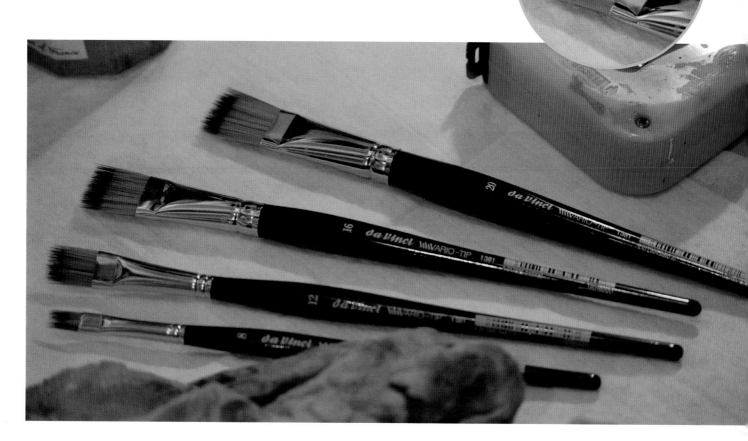

ACRYLIC VARNISH

If you prefer a certain manufacturer's acrylic paint and money is no object, invest in at least two types of acrylic varnish. I use either a gloss or a matt varnish to counteract the situations outlined on page 14, and finish the whole painting with one or the other by applying it with a clean, broad brush. The other types are satin or silk, which are between gloss and matt.

Varnishes give the paint a little protection but, more importantly, they enhance the colour and texture of a painting. If the picture is going to hang in a non-reflective position, I use gloss varnish because of its magnifying effect on the image.

WORKING FROM PHOTOGRAPHS

Most of us are limited to the automatic settings of our SLR or phone cameras, and photographs don't always tell the truth in terms of the colour and character of the dog. They can foreshorten features and change size and perspective, producing large noses or small ears. Dogs are not the most patient of sitters, unless they are asleep, so I like to meet and greet my subjects and then work from a series of photographs. This involves a lot of travelling, but is also great fun.

MY MEET-AND-GREET PROCESS

· Arrive, greet the owners and say hello to the dogs! This usually involves being barked at, sniffed and played with so that after twenty minutes, the dogs are happy to have me around.

· If they are not happy, getting photographs can be a nightmare. If there is more than one dog, find out from the owner the relative characters; for instance, who is Top Dog, who is Teacher's Pet and who is Princess!

· Find out the size and aspect of the canvas, where it is going to hang and where the light is coming from relative to this position.

· If it is not going to hang in this house, find out the owner's favourite colour or décor colours.

· Using all that information, you are now looking for photographs which will tell the above story.

· I don't always look for the perfect photograph, but I do try to get pictures of the key features so there is enough reference material. The photographs listed in the chart opposite, taken at the dog's head height, will normally cover most features.

· Five minutes at the end of the session to check that I have all of the above.

· If it's a commission, I get agreement for a deposit of ten per cent.

Of course, if the dogs have passed away, you have to rely on the owner's photographs; in this case, all but the first two points need to be discussed, usually over a cup of tea!

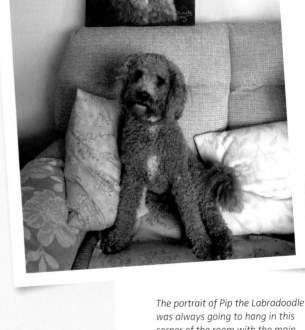

The portrait of Pip the Labradoodle was always going to hang in this corner of the room with the main picture window lighting it from the right. The painting is shown on page 75.

• *What photographs do you need?*	• *Why?*
• Forty-five degrees looking left to right, showing both eyes, with light from the required side.	• If there are markings on the muzzle, you need to know what they are like on both sides. The number of whiskers is also sometimes different.
• Forty-five degrees looking right to left, showing both eyes, with light from the required side.	• Having the light coming from both sides will show certain changes in the fur.
• True colour of the fur, taken outside.	• If the dog's coat is reflective, photographs can show false colours – for instance, green grass reflects into the coat so be aware of this.
• The eye colour, usually taken inside.	• Outside in bright light, eyes usually close down and sometimes you can't see any colour.
• Photographs with the tongue in and out.	• This issue might not come up in your early conversations about the painting, so get both.
• All the dogs sitting or all standing so you can see their relative heights.	• Relative heights can be a nightmare, so you might need to get the owner to offer a treat to get all the dogs to sit or stand.
• The room and wall where the painting is intended to hang.	• So that you can match the background colour of the painting to the room décor.
• A straight-on photograph of the face.	• Sometimes the owner wants the painting on a square canvas; this type of photograph on the left gives all the reference you need.
• A photograph of a favourite location.	• Sometimes the owner would like the painting set in specific a location, so you need their photograph or details of the scene so that you can capture it.

The reference photograph for the Alfie project on page 104.

- *Tips on taking photographs*

- Do take the dogs outside one at a time to be photographed. Don't allow mayhem to ensue with them all there until you have your individual shots.

- Do check that the poop has been scooped... there is nothing worse than treading it back into the house.

- Do check where the sun is and make sure your back is to it.

- Do ask the owner to bring treats down to eye level to attract the dog's attention, otherwise your photographs will have them all looking heavenward. Trying to paint dogs photographed from below is also a nightmare so...

- ...do kneel down to take the photographs at the dog's head height.

- Do set your camera to the Sports or Burst setting and select a low or medium image size; the more shots you take, the more likely you are to get what you need.

- Do focus on the dog's face by half depressing the shutter button before taking the photograph, otherwise the background may be in focus rather than the dog.

- Do have a spare battery with you and don't carry a lot of other photographs on your memory card, or you might run out of space.

- Do make a note of dogs' names in the order of the photographs; there's nothing worse than having to sort out who is who after the fact.

- If the dogs are obedient, do get the owner to come behind you and move the treat from left to right while you get the shots you need.

- Do avoid the use of flash. It not only disturbs the dogs, but the white light is artificial on the coat and will create red-eye in the photograph.

- Don't be surprised if you have to take more photographs!

- If they won't look your way, have dried food to hand and make a noise to attract their attention. I purse my lips and draw in breath, which sounds a bit squeaky and probably looks hilarious, but makes the dogs look at me with their ears alert.

- Be aware that a dog lying with its ears back, lip-licking or showing the whites of its eyes is probably afraid of the camera or your weird noise. Avoid these looks in the final painting.

Most of us want to shoot the perfect photograph and paint that, but the perfect photograph rarely exists. You might have a good picture of the dog's fur colour, taken outside, but the eyes are in shadow and their true colour doesn't show. My objective is to reconstruct the dog from a number of photographs and paint its image to enhance the room in which the painting will hang. Sometimes, of course, I accept that you have no alternative but to reproduce the image from one photograph.

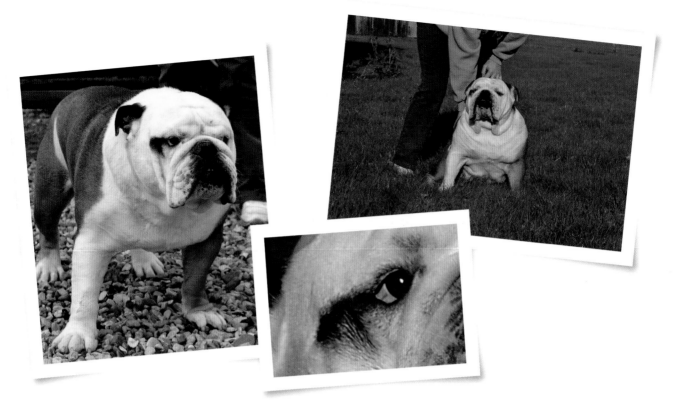

I used these three photographs as reference for my painting of Diesel the English Bulldog, shown below.

DIESEL – ENGLISH BULLDOG
61 x 45.7cm (24 x 18in)

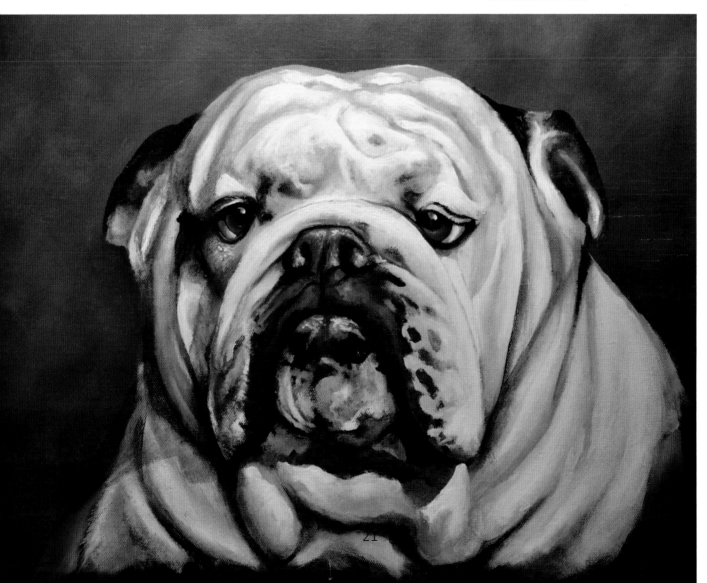

21

At the Crufts dog show in 2011 a woman asked me to create a painting of five dogs, to be delivered at Crufts 2012 in time for her husband's 50th birthday – but it was to be a surprise. The difficulty was that the couple lived 150 miles from me and her husband worked from home, so we needed to find a day when he would be out so that I could go and meet the dogs. However, the opportunity arose when he would be playing golf, albeit locally, for four to five hours. I started out early to arrive after he left, had about two hours' meet and greet and then left before he got back! The day had mixed weather, so the photographs were inconsistent in terms of light and colour. I had to mix and match elements of the photographs, taking an ear here or an eye there, to construct each dog's image and then light them all from the left.

Having never met the husband, I received a text at Crufts 2012 to say the couple were on the way in. I looked up and saw the woman with a man whose arm was slowly rising and pointing at the painting on my exhibition stand. He was mouthing the words, 'That's my dogs!' He soon had a smile on his face, but there were lots of tears when he realized that his very special present had been a year in the making and he had had no idea!

JOEY, DARCY, TOBY, TRIXIE AND ALPHONSE
91.4 x 61cm (36 x 24in)

From left to right: 'happy-go-lucky' Joey, 'Princess' Darcy, 'Dad' Toby, 'Nervous Nervosa' Trixie and 'Musketeer' Fonzie.

THE BACKGROUND

If you want to bring something forward, you need to give it a great behind! There is nothing more critical to creating a great portrait than the quality of the background. If the background is wrong, the subject won't work. By 'wrong', I mean there are brush marks, blank canvas or unblended paint showing or the wrong colour has been used. It's therefore worthwhile spending time thinking about and executing a great background.

WHAT COLOUR BACKGROUND SHOULD I CHOOSE?

There are so many options, and here are a few ideas to wet your whistle!

- A colour sympathetic or close to that of the dog – so a brown dog might work with a dark brown background behind it.

- A complementary colour – a greyed version of the opposite colour on the colour wheel brings the subject forward. You might use a greyed blue for an amber dog or a greyed gold for a blue-black dog.

- A colour sympathetic to the décor of the room where the painting will hang.

- The favourite colour of the receiver of the painting. People like colours for many reasons, such as a favourite football team or the colour that goes best with their skin tone or hair. The favourite colour will often adorn their rooms.

- The colour that can be seen outside the room, for example the garden. We have an evergreen hedge visible from our neutrally coloured lounge, so in the painting shown of our dog Alfie on page 35, I used the hedge colour as a background to bring the painting and the outside together.

- The colours of a particular scene. I was once asked to paint a fictitious background scene joining two Scottish landscape paintings that would be placed either side of the dog portrait. This prescription of colour made the job easier.

BARNEY AND BRACKEN – ENGLISH SPRINGERS
91.4 x 61cm (36 x 24in)

The dark background and strong lighting on the subjects in this painting bring out the statuesque, three-dimensional look.

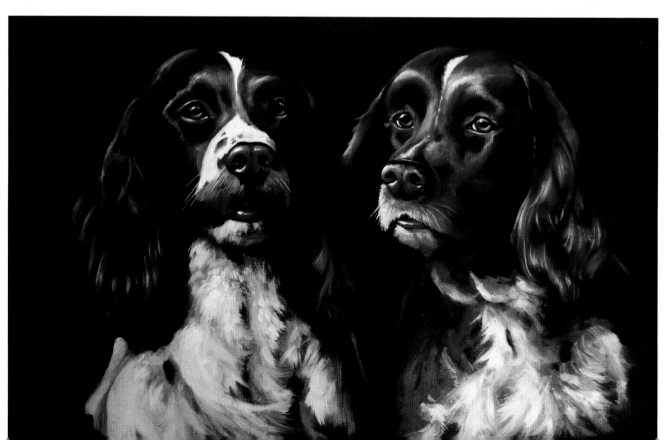

I tend to choose darker backgrounds for most of my paintings because this pushes a subject forwards, while a light background will absorb the subject or make it recede. However, as you can see from the painting shown below, if the subject is even lighter than the light background, you can still get it to project by carefully balancing the tones of the painting. The English Setter on the left seems to project more than the Springer, because the dark coat of the Springer is absorbed and dominated by the background.

When you want to make the subject more three-dimensional, in most cases darker backgrounds will help to promote this.

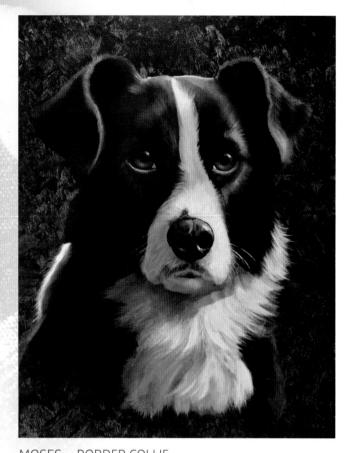

MOSES – BORDER COLLIE
50.8 x 40.6cm (20 x 16in)

This painting of Moses was a surprise birthday gift from a best friend to a woman who came all the way from New Zealand to get it. No pressure!

LUCY AND MILLIE – ENGLISH SETTER AND SPRINGER
91.4 x 61cm (36 x 24in)

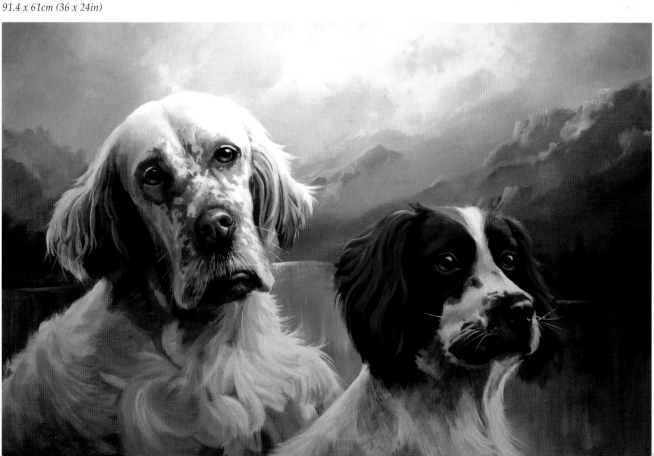

• Ten top tips for backgrounds

1 Completely cover your support with acrylic to seal it before painting the background. This slows the drying times for later coats because the surface is no longer absorbent. Let it completely dry, then paint the first proper colour smoothly on top.

2 The first coat should be close in colour to the last.

3 Use a 25mm (1in) or 50mm (2in) brush to paint a background, depending on the size of the canvas. The larger the brush, the easier it is to blend colours and distribute paint for a smooth finish.

4 Mix your paints thoroughly in the palette before applying them, to avoid stripes of unmixed colour.

5 Choose a light source for the painting to match the light source in the room. If there is a south-facing window to the left of the wall on which the painting will hang, light the background from the left. If you can match the angle of the light in your brushstrokes, even better!

6 Do a graduated background and soften the change between tones so you can't see the join. This will bring forwards a hard-edged subject and make it look three-dimensional.

7 If using a canvas, paint round the side edges as you go. This allows viewers to see the image from different angles and places it more firmly in the room.

8 Do a second background on top of the first, because the first one will have blemishes such as brush marks.

9 Add a little more water to the mix to make the brushstroke last longer and blend better. However, if there is too much water in the brush it will pour down the canvas, especially if you press hard.

10 You will need less paint for the final coat because of the background already underneath.

FLIN – ROUGH COLLIE
61 x 45.7cm (24 x 18in)
The background was not only designed to go with Flin's fur but also with the wallpaper in the room.

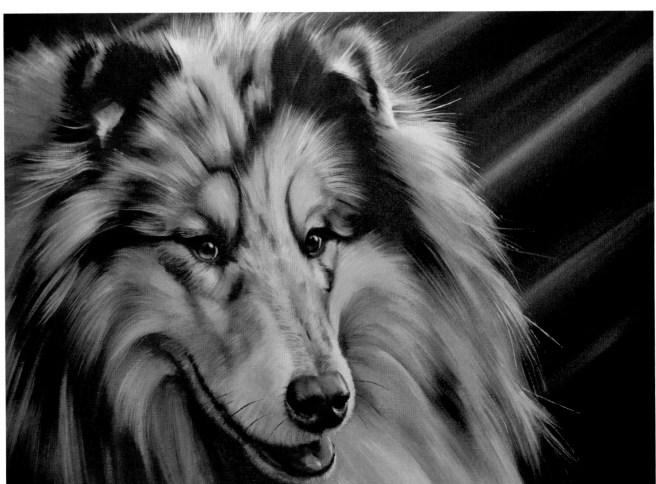

A GRADUATED BACKGROUND

This is the graduated background for the Demelza and Kenzie project on page 118.

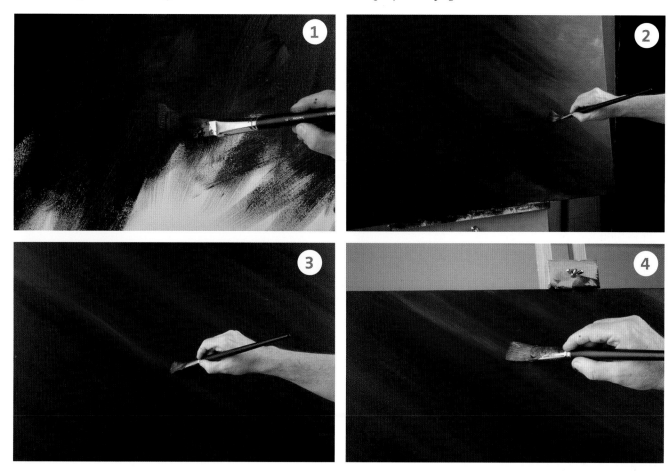

1 Mix a dark brown from Mars black and cadmium red deep and use a 2.5cm (1in) flat brush to cover and seal the whole block canvas, including the edges, with quick brushstrokes. Allow to dry.

2 Now paint diagonally from top left to bottom right, with long, smooth brushstrokes. This creates a base into which you will blend subsequent brushstrokes.

3 Add more cadmium red deep to the mix and paint further diagonal strokes, blending into the wet background.

4 Add streaks of metallic copper and, again, blend into the background with long, smooth strokes.

5 Now apply rich gold metallic paint in the same way.

6 Finally, paint on a few streaks of pale gold and blend in with smooth, repeated strokes. Make sure you have painted the edges of the block canvas in the same way, and allow to dry.

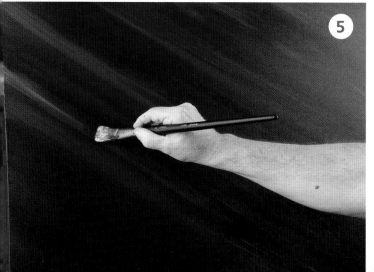

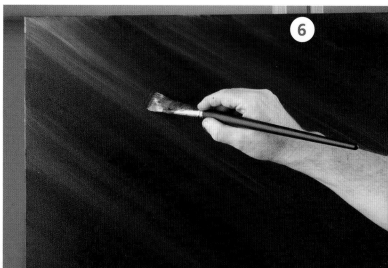

This is my portrait of Huskies Skye and JJ (right). The dogs' owner is an architect who has two passions: his dogs and his Formula Ford racing cars, one copper and the other gold-coloured, which were parked in his driveway when I arrived to meet him. The interior colours of the house were mainly neutrals, but the cars gave me an idea for the background. It seemed appropriate to brighten the room and the painting with copper and gold, so that four great loves were represented in one picture! One of the joys of acrylics is that you can use metallic colours to lift an aspect of the painting – in this case the background.

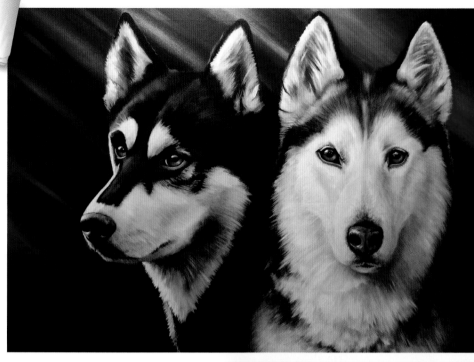

SKYE AND JJ – HUSKIES
91.4 x 61cm (36 x 24in)

When I met Bart (left), his owner came to the door dressed in what I can only describe as a Swinging Sixties flower-child trouser suit in stunning reds and oranges. The room where the painting would hang was a relatively dark kitchen, so what better way to brighten it than to replicate the owner's favourite colours, which also match Bart's eyes!

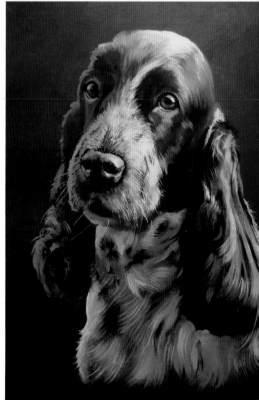

BENJI – BLUE ROAN COCKER SPANIEL
91.4 x 61cm (36 x 24in)

The family who own Benji are avid supporters of AFC Bournemouth, the football club, who are nicknamed 'The Cherries' because of the colour of their shirts. I have graduated this colour to a dark cherry to represent black, the other colour the team wear.

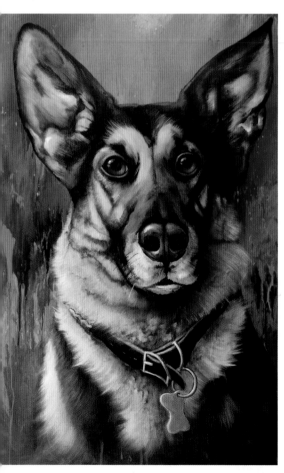

BARTHOLEMEW – GERMAN SHEPHERD
91.4 x 61cm (36 x 24in)

I was asked to prepare a contemporary painting for an exhibition on the Newfoundland breed in 2013, held in the Kennel Club's Art Gallery. It needed the three main types of Newfoundland, but had to be modern! The word 'contemporary' shouts Jack Vettriano to me so I used the style and colours of his painting 'The Billy Boys'. I even matched the dogs' colours to the clothing of some of the figures in the painting and put them all on my favourite beach, opposite the Isle of Wight (see right).

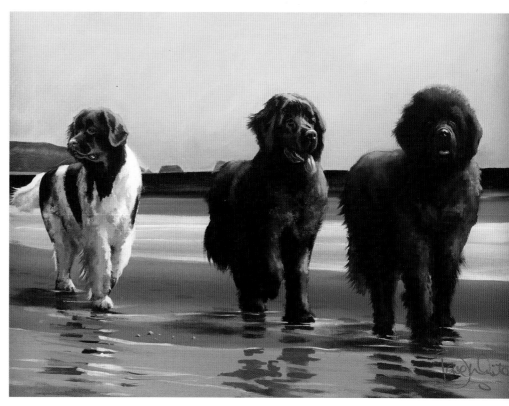

THE NEWFIE BOYS –
NEWFOUNDLANDS
61 x 45.7cm (24 x 18in)

COCO AND HOLLY – LABRADOODLES
81.3 x 50.8cm (32 x 20in)

The owner of the painting below writes: 'I commissioned Dave to paint my son's two labradoodles, Coco and Holly. The question of a suitable pose and background was discussed and agreed with my son. The background was to go with the view of the harbour from their home.'

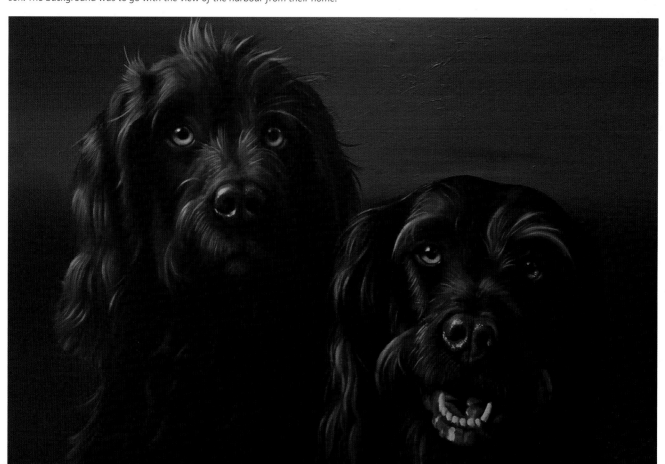

LIGHT AND SHADE

One of the key ways to make a subject look three-dimensional is to light it from a certain angle and stick with the effect throughout the painting. If the light source is a south-facing window, this decides the graduation of colour tone in the background, and you need to paint all the left-hand edges of the subject lighter: the left-hand edge of the left ear, muzzle, nose and chin. If part of the painting is lit from a different direction, it will look out of place.

You then need to concentrate on smaller features such as eyelids, nostrils, layers of chest hair (which protrude on hairier dogs) and eyes. All these finer details need to be lit consistently with the rest.

There are, however, influences on light and shade in addition to the main light source: reflections. If you place a light-coloured dog next to a dark dog with a reflective coat, the light colour can reflect in the dark coat on the opposite side to the main light source. This can happen if you put a Golden Retriever next to a shiny black Labrador. Showing this in a painting binds the subjects together and creates interest, but it is best to reduce the strength of this reflective light effect so that it is secondary to the main light source.

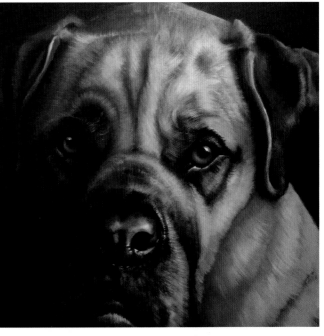

TRAVIS –
ENGLISH MASTIFF
50.8 x 50.8cm (20 x 20in)

Emphasizing Travis's 'dark side' allowed me to make the head more three-dimensional by highlighting his colour on the lit side.

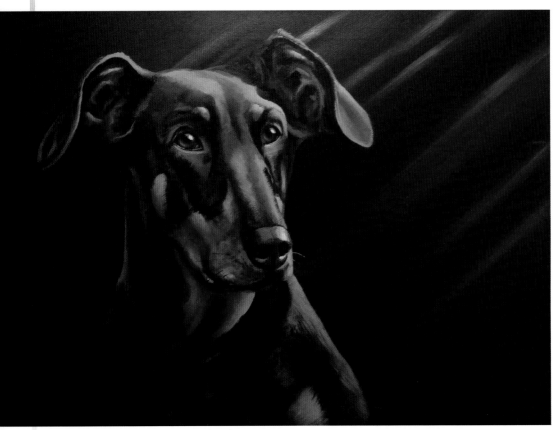

TEACHER – DOBERMAN
61 x 45.7cm (24 x 18in)

When you use a dark background, it allows you to highlight the colours of a dark dog so that they project out more.

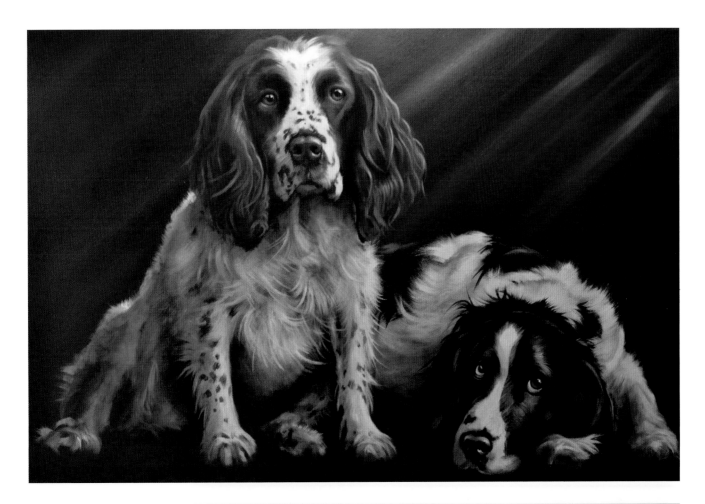

NEVILLE AND WALLACE – ENGLISH SPRINGERS
91.4 x 61cm (36 x 24in)

You can use light and shade to separate animals in a composition. Giving the dogs different positions also creates interest. Neville on the right was always the last to get up for walks!

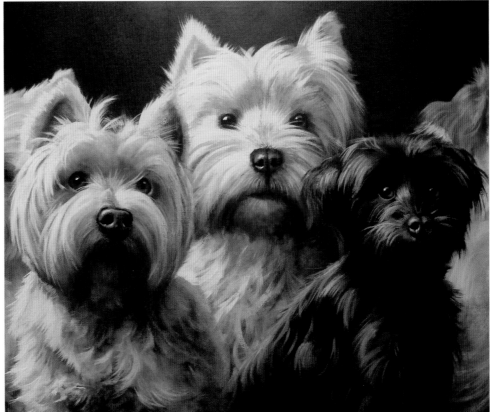

If you look at the two dogs in the front of this painting (also shown on pages 22–23) you will see that the reflective dark coat of Trixie (right) picks up the light coat of Darcy (far left) and vice versa.

This painting of Lily is one of my most interesting light and shade portraits. I was told Lily was shy of cameras, but after a meet and greet, she was a proper little model and did everything I asked. We had a glorious photo shoot in very bright, sunny conditions. You can see that she is a blue-white but with very red ears, so I reddened the background to go with her ears. She also had a black shiny nose, so I was able to put plenty of sky reflection into it to go with the blue-white shadows in her fur.

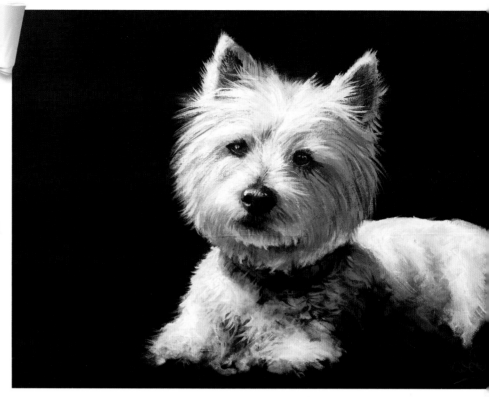

LILY – WEST HIGHLAND TERRIER
50.8 x 40.6cm (20 x 16in)

Just as black dogs are either a blue- or a red-black, Lily is a blue-white, and this is exaggerated to make her look more three-dimensional.

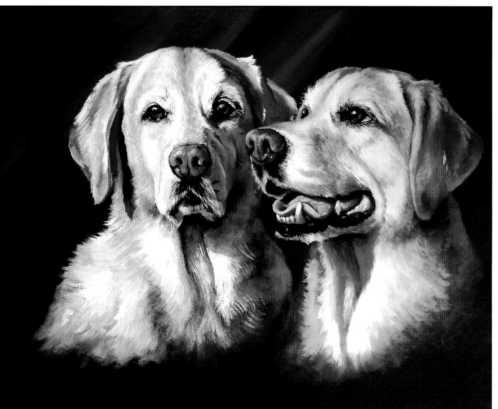

RUPERT AND WHISPER – GOLDEN LABRADORS
61 x 45.7cm (24 x 18in)

The light for Rupert and Whisper was assumed to be coming slightly from the left, behind the viewer. The dogs were nine when their owner asked me to paint them. He sent me photographs and I assumed they were all of one dog. It turned out that the dogs were brother and sister from the same litter. I said I had to meet them and he brought them over. They both had the onset of arthritis and had to be lifted from the car, but you could immediately see that Rupert was the serious one and Whisper was happy-go-lucky.

CLEM AND HORATIO – POODLE AND TIBETAN TERRIER
91.4 x 61cm (36 x 24in)

Both Clem and Horatio have hair problems, in that they have to have it tied back so that they can see! The painting was going into a lounge with a red leather suite and a lot of 'bling'. I chose to create a background with a poured mixture of gold, copper and red.

The natural light for Clem and Horatio, shown here, came from a small window to the right, so I painted them lit from right to left.

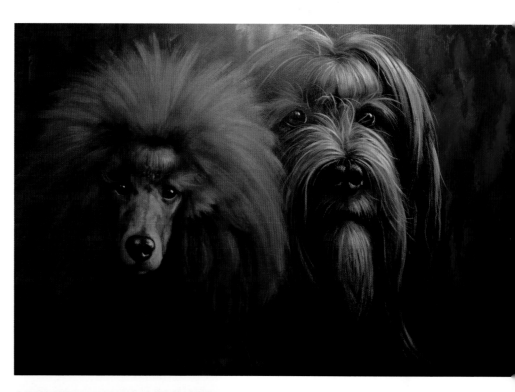

BARKLEY – MINIATURE POODLE
50.8 x 40.6cm (20 x 16in)

Barkley's colour was golden in the sun and I wanted to burnish that gold through the painting, so the dark is the colour of that gold at its darkest.

This painting of Barkley was commissioned by a man as a Christmas present for his wife. The background colour was designed to go with Barkley's colours. To make the painting look spectacular, I also graduated the background with golds and coppers to make it highly reflective when light hit it.

When he received the painting, the client admits that he was a little disappointed at first as it seemed rather dark. However, 'When I put it under a spotlight, it shone and Barkley stared back at me. I bought a picture light, hung the painting and unveiled it on Christmas day. It may be the best present Heather has ever received.'

THE OUTLINE

The outline defines the area of the subject and provides a relative sizing guide to the key features of that subject. In most other media, artists draw their outlines before doing the background because a drawing material such as pencil will not adhere to a background in oil or pastel. But here acrylics come into their own because, once a background is dry, you can draw on top of it with pencil, chalk or pastel. I draw with ordinary white blackboard chalk – it's cheap and easy to rub or wash off and it stands out clearly on most dark backgrounds.

There are many methods you can use to replicate an image from a photograph: gridlines, tracing or transfer paper and even special projectors for enlarging. However, I use something a bit more mathematical.

Some artists are blessed with the ability to draw freehand and produce an image in proportion, but most of us need a system which allows us to check sizes and proportions as we proceed and especially when we have finished.

TIP

If you can't recognize the animal from the outline, the painting will not work!

AMBER AND BERRY – WORKING COCKER SPANIELS
61 x 45.7cm (24 x 18in)

Unusually here, I painted the outline with the dogs looking away from the viewer, because Amber and Berry are working dogs and they are not allowed to be distracted.

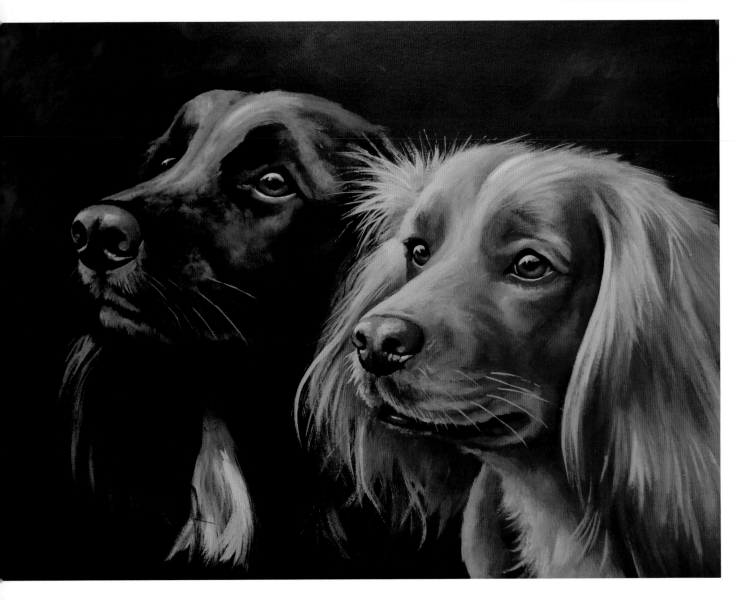

Say you want to copy the content of a 15.2 x 10cm (6 x 4in) photograph on to a 61 x 45.7cm (24 x 18in) canvas. The proportions are not quite right to transfer the whole content, since the equivalent canvas to the photograph would be 61 x 40.6cm (24 x 16in). You could multiply the sizes by 4 (since 24/6 = 4) but you would be left with 5cm (2in) at the top or bottom. If you tried to squeeze the whole photograph into the canvas, the resulting image would be thinner than the original. So instead of trying to transfer all of the background from the photograph, you just transfer the main image.

I adopt the 'multiply by 4' Method (see Outline Method 1, overleaf), but just for the measurements of the main subject. There are two key measurements: the width of the head and the length from the top of the head to the base of the image. Those two measurements will set the scope of the subject on the canvas, so multiply both by 4 and you have a new proportional size for your subject. But where would you position that image on your canvas? There are compositional guidelines to help with this.

COMPOSITION

To make the subject visually acceptable, it is not normally a good idea to set the image directly in the middle of the painting. This does work, however, if you are using a symmetrical format like a square canvas, but rectangular canvases need more consideration.

I tend to use the golden ratio or rule of thirds system, dividing the rectangle into thirds horizontally and vertically. I place the dominant eye of the subject on any one of the four points where the lines intersect. However, as you can see from the photograph (right), the dog's eye in the photograph does not lie on the convenient third. If we moved the image to the left so the eye was on the upper left third, we would lose some of the nose. If we moved the image to the lower right third, we would lose some of the mouth. So, the natural point to move the eye to would be the upper right third. We would then lose some of the ear, but all the key features would be included. If you wanted more of the ear included, instead of multiplying the image measurements by 4, you could create a smaller image by multiplying by 3. However, that would make the image too small for the size of support and the subject would get a little lost in the painting. Also, note this particular photograph is missing a bit of the ear, so if you wanted to use this last method, you would need more information to portray the ear accurately.

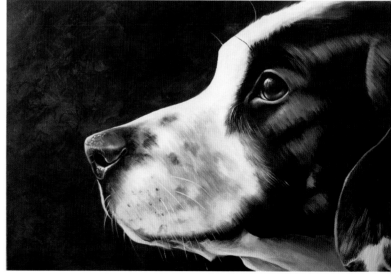

In this finished painting of Alfie, I repositioned the head so that the eye is on the top-right point of intersection, which makes a more pleasing composition. The painting also appears on page 116.

OUTLINE METHOD 1: MULTIPLYING MEASUREMENTS

THE KEY MEASUREMENTS FOR ALFIE (PAGE 35) WOULD BE:

A: Centre eye to top of head
B: Top of head to chin
C: Centre of eye across to end
 of nose

D: Top of nose to lower jaw
N: Top to bottom of nose
EW: Eye width
EH: Eye height

In each case, measure the distance on the photograph and multiply it by 4 to establish the measurement on the canvas.

Having painted the background and plotted the top-right intersection of the thirds, we can now start to transfer the key features. Make chalk marks for A–D, then place the smaller details of nose and eye width and height (N, EW and EH). Join the dots freehand, replicating angles and curves from the photograph. The outline will be simple at this stage, but ensures that all the main features are in proportion to each other. I add minor features like spots and other markings using the same method but at a later stage, after the main features have been painted in the underpainting.

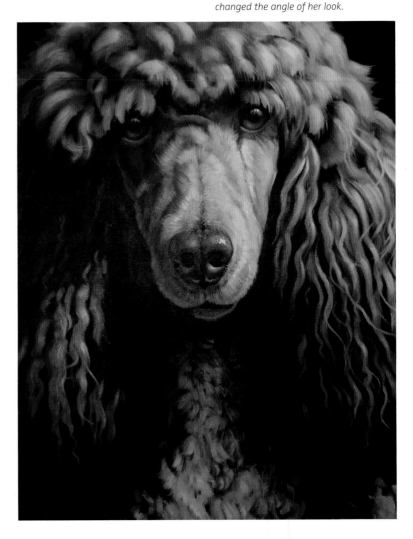

DAISY – STANDARD POODLE
76.2 x 50.8cm (30 x 20in)

This large painting was to hang in an atrium, so I wanted Daisy looking down. The owners also wanted me to exaggerate the length of her muzzle, so I changed the angle of her look.

METHOD 2: USING GRIDS

If you are confident at drawing, you could use the grid method of transferring the image. Remap the third intersections on the photograph using the top-right intersection for the eye. As discussed, you will lose a part of the photograph. Then divide your canvas into thirds as you did for the photograph. Now freehand draw the outline in chalk by plotting where the dog's features intersect with the revised thirds on the photograph. This is a slightly looser way of transferring the image but has its check method and doesn't require a calculator.

Once you have gained confidence with this method, you can use an even looser technique. Too many boxes can hide the overall image and the process becomes a technical drawing exercise and not so enjoyable. For the painting on the right, I used diagonal lines from corner to corner to map the outline, observing where the main points of the image crossed the lines.

WILLOW

For this project (page 92) I created diagonal lines on a reduced-size photograph from which I noted the following key points:

- The left eye touches halfway up the upper left-hand diagonal.
- The top of the right eye is at same height as the corner of the left eye, runs along the right-hand upper diagonal and ends halfway up it.
- The left-hand nose edge is slightly to the left of the central cross.
- The left-hand lower diagonal runs through the left nostril.
- The right-hand lower diagonal runs along the right-hand nostril's lower edge.
- The mouth line is halfway between the bottom of the canvas and the central cross.
- The left-hand edge of the muzzle is halfway between where the edge of the left eye touches the left-hand diagonal and the central cross.
- The right-hand edge of the mouth is directly below the right-hand edge of the nose.
- The left-hand edge the of mouth is directly below the right-hand corner of the left eye.

I painted a dark background using ultramarine and Mars black on a 60 x 60cm (23⅝ x 23⅝in) block canvas, left it to dry, then drew diagonal chalk lines from corner to corner and plotted the main points noted above onto the canvas. You can check your resulting image against these coordinates and double-check the size of the eyes and nose to make sure they are in proportion with the photograph.

Details such as eyebrows and ears relate to these key coordinates and can be added once they have been established.

As the photograph is square, you can use this method to reproduce the image on any size of square canvas because the diagonals work with any square.

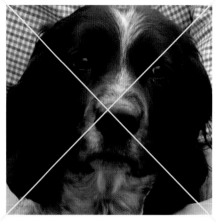

The reference photograph (above) and the outline (below) for the Willow project.

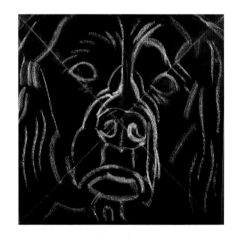

TIP

If you have a large rectangular canvas, you can use the same method by drawing a chalked square area within it.

METHOD 3: PAPER MEASUREMENTS

If you are not so good at numbers, you might like to use this method. Mark the actual photograph measurements A–D onto a narrow piece of paper by simply putting the paper on the photograph and marking the distances from one end of the paper with the appropriate letter. Then transfer those distances onto the canvas by simply moving the lines on the paper four times from the various coordinates. It's a bit fingers and thumbs, but it is simple and there is no calculator involved. You'll find it's easier to do this with a larger photograph so that the distances are more significant and can be clearly seen.

CREATING THE OUTLINE FOR MORE THAN ONE DOG

When you are composing a painting of several dogs, consider the character of the dogs and the relationships between them. There are many discussions in the dog training world as to whether there is such a thing as an alpha male or a pack mentality. All I know is that dogs have characteristics which define them in relationship to other household dogs. These are some of the character types:

- King or Queen – They rule the roost, come first and tell everyone where they are going wrong! They play the parent role, sometimes because they are the actual parent.

- Prince or Princess – The good-looking one who preens the most. When a camera enters the room, they turn into a model!

- Warrior – Defender of the pack, the first into the fight. Fights to be first in line but often told off by King or Queen. Mysterious cuts, bruises and scars appear on these characters!

- Musketeer – Thinks he or she is a warrior but is actually a weakling. Good-looking but with no standing. These dogs like a game and will chase anything!

- Layabout – Can't be bothered to get up for anything or anyone.

- Nervous Nervosa – The shaky one, usually the smallest but often the most cared for.

POPPY AND TIG – WEST HIGHLAND TERRIERS
91.4 x 61cm (36 x 24in)

Poppy and Tig had matching warm-coloured coats of a red-white so I was able to overlap their outline and not lose the colour of one in the other.

All of these characters have their place in the group, and it either pushes them to the back, puts them on the fringe or brings them centre stage. To portray this, you need to position them carefully in the painting. Sometimes another consideration, such as a marking on one side of the face defines where a dog needs to go in a painting and which way it should look.

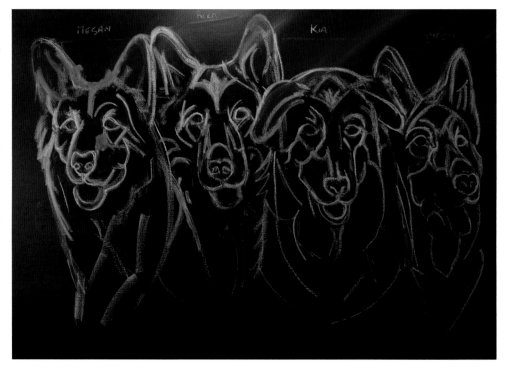

Once you have finished the outline, write in the names of the dogs. The finished painting of Meg, Rika, Kia and Gypsy is shown on page 13.

Having established an outline on a background, I would photograph the painting and send it as first draft to the customer. Ask:

- Do they like the background colours?

- Do they like the composition of their dog(s) and recognize their characteristics in their positioning?

- Do they recognize their individual dogs from the outline?

- If there is more than one dog, are the relative heights and sizes correct?

It is better to know now if there are any problems. If the customer doesn't like the background, make sure you know why, and be prepared to repaint it. If the chalk images need amending, add the new lines while you still have the old ones on, then rub the old ones out with a wet towel once you are happy with the new ones. That way you don't reproduce what you have already done. If the customer has recognized who is who from the outline, write the names in chalk above the images so you don't forget.

CHAOS AND HAVOC – NOVA SCOTIA DUCK TOLLING RETRIEVERS
61 x 45.7 (24 x 18in)

Chaos was always first, so by placing Havoc behind with heavy shadowing, I was able to bring Chaos forwards.

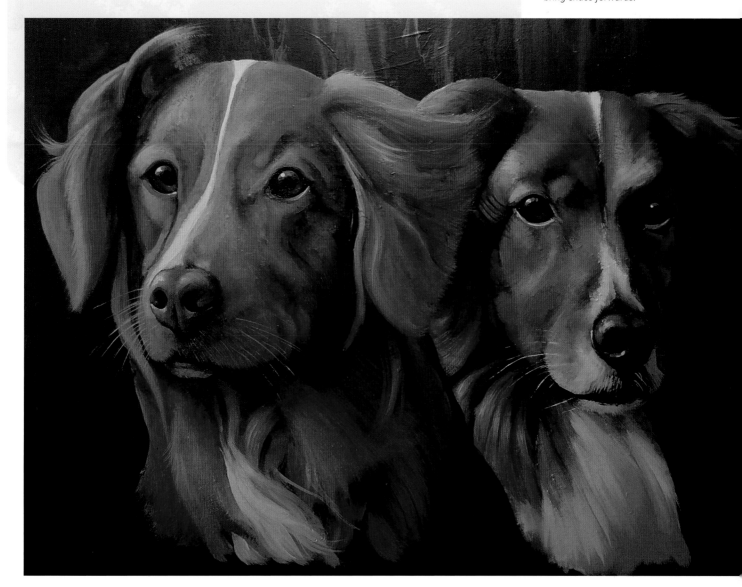

UNDERPAINTING

The underpainting represents the colours which are underneath the fur, inside the ears, behind the eyes, at the back of the mouth and behind the nose. They are not the colours that you can easily see on the surface and which most artists might start with. They represent the shadows or the foundation colours of the top coat. This part of the process requires you to look hard at the image to see what colours are actually underneath the surface.

In some cases, it's worth outlining in chalk the areas where you believe these colours change, to create, if you like, a topographical map of the dog. This stage of the process can be quite loose as these colours will only be seen as supporting colours, with texture and the top coat painted over them. However, the colours in the underpainting are essential in order to project the top colours out to the viewer and add a third dimension to the painting.

**JESS AND JASPER –
LABRADOR CROSS**
61 x 45.7cm (24 x 18in)

The darker colours in both Jess and Jasper's faces were created by the underpainting left to come through the top colours.

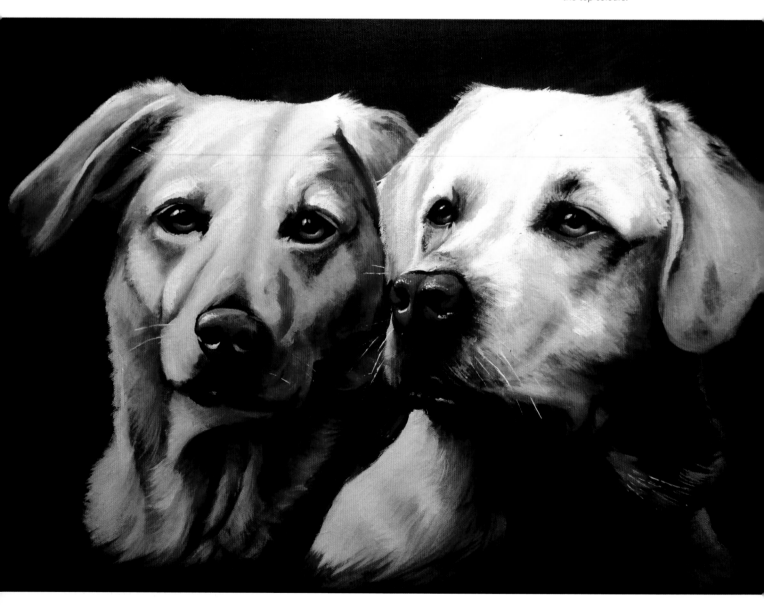

Here are a few examples of underpainting colours to consider:

- The background to the eye is usually a very dark blue or red-black. It is seen inside the pupil and between the eyeball and the socket, so paint the whole area within the socket that colour.

- The nose is very similar but may be a different dark colour.

- The fur of a white dog often reveals the pink of the skin through it, so you might have various tones of pink in the underpainting.

- The blotches of a Springer's markings are often mottled throughout the rest of its body, so paint that same colour on a wider basis in the underpainting.

- A black dog usually has a lot of dark underneath the top coat. Look for whether the top coat is a blue- or red-black and paint the underpainting a different black.

ALFIE – GOLDEN RETRIEVER
61 x 45.7cm (24 x 18in)

Alfie is a golden colour rather than blond. Layering the undercolours deepens the colours of the dog to make them truer.

41

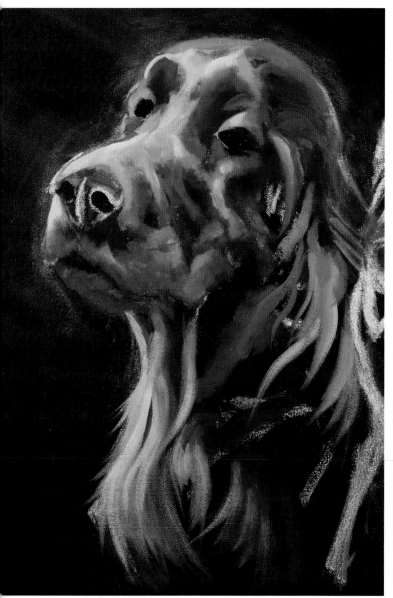

Demelza with the underpainting finished.

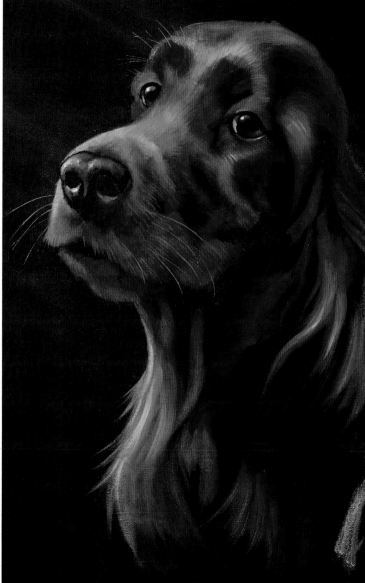

Demelza finished.

Above, left, is the underpainting for Demelza, for the Demelza and Kenzie project shown on page 118. Since Demelza was to be further back and Kenzie needed to come forwards, I made sure that the underpainting for Demelza created less tonal contrast. Above, right, is Demelza after I glazed over the underpainting with transparent burnt sienna and painted all the details of hair, nose, eyes and whiskers.

You will notice how the chalk can migrate and apparently smudge into the background when you do the underpainting. However, once you have painted the middle and top coats and let them dry, you can simply wash the chalk off and it leaves the pure background colours. Gentle rubbing with a rag will take the remainder away.

TIP

The more you blend the underpainted colours, the more three-dimensional the final image will look, but don't send it to your customer yet! At this stage the dog will have no eyes and will be blotchy.

TRUE TALES

Long-haired German Shepherds often have warm-coloured dark hair underneath a lighter top coat and then very light-coloured hair on top of that. The finished painting of Bartholomew (right) appears on page 28, but here you can see some of the underpainting. The trick to creating a thick coat is identifying which colours are underneath and which are on top. In Bart's body, the dark areas are underneath, so I put the dark shades in the underpainting. On the face, the surface colours are darker, so I painted these in later.

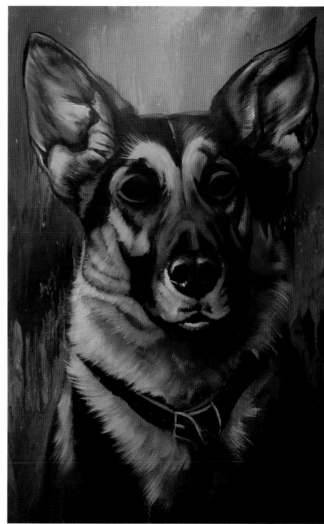

BARTHOLEMEW – GERMAN SHEPHERD
91.4 x 61cm (36 x 24in)

The photograph was taken when some of the top coat of hair had been added, but the dark underpainting is still showing in places.

JANGO, GUNDO AND KYRA – GERMAN SHEPHERDS
91.4 x 61cm (36 x 24in)

The client who commissioned this painting wrote to me later: 'As neither Gundo nor Kyra are with us any longer, it makes me smile when I look at it. I feel that I could stroke them, and am always talking to them!'

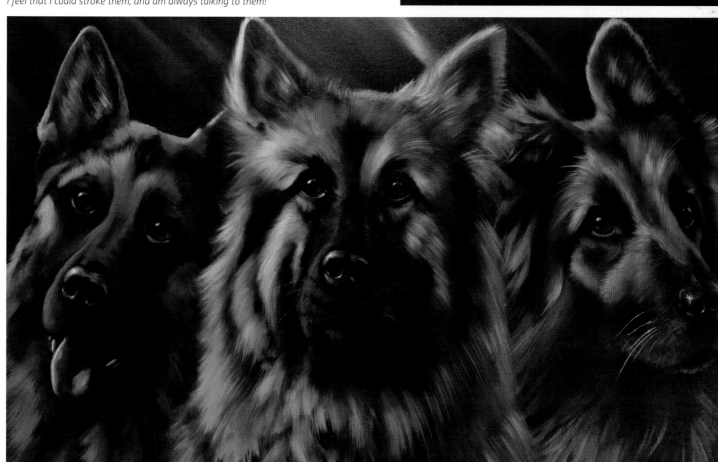

HAIR

We come to the thorny subject of hair, or should I say, fur? In my view, fur is short and tight to the skin, while hair is long and flowing. There are some dogs who have very tight hair which seems so close to the skin that it is like velvet: these include Beagles, Doberman and Bulldogs. I call this type fur.

Then there are long-haired varieties in which the hair is very distinct, such as Afghans, Bearded Collies and English Sheepdogs. I call this type hair.

These two extremes create very different painting demands. Then there are dogs which have a mix of the two, such as the Chinese Crested (see opposite). Nevertheless, both require the approach of creating an underpainting first before painting the top coat.

Opposite
CONRAD – CHINESE CRESTED
61 x 45.7cm (24 x 18in)

Conrad's coat is a mix of long hair and no hair. The breed standard for both hairless and powderpuff varieties suggests a crest of fine hair running from the head and down the neck to the withers, so Conrad is a typical example of a hairless, despite the flowing locks! The full-coated powderpuff variety has a body covered entirely by a fine veil of hair.

CHILLI – YORKSHIRE TERRIER
50.8 x 40.6cm (20 x 16in)

A Yorkshire Terrier's hair can be either wiry or soft. It is highly reflective, so there are lots of highlights where the hair bends towards the light

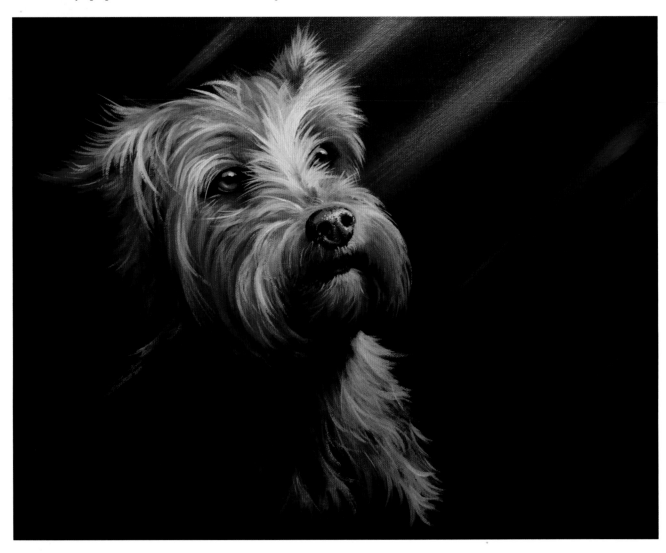

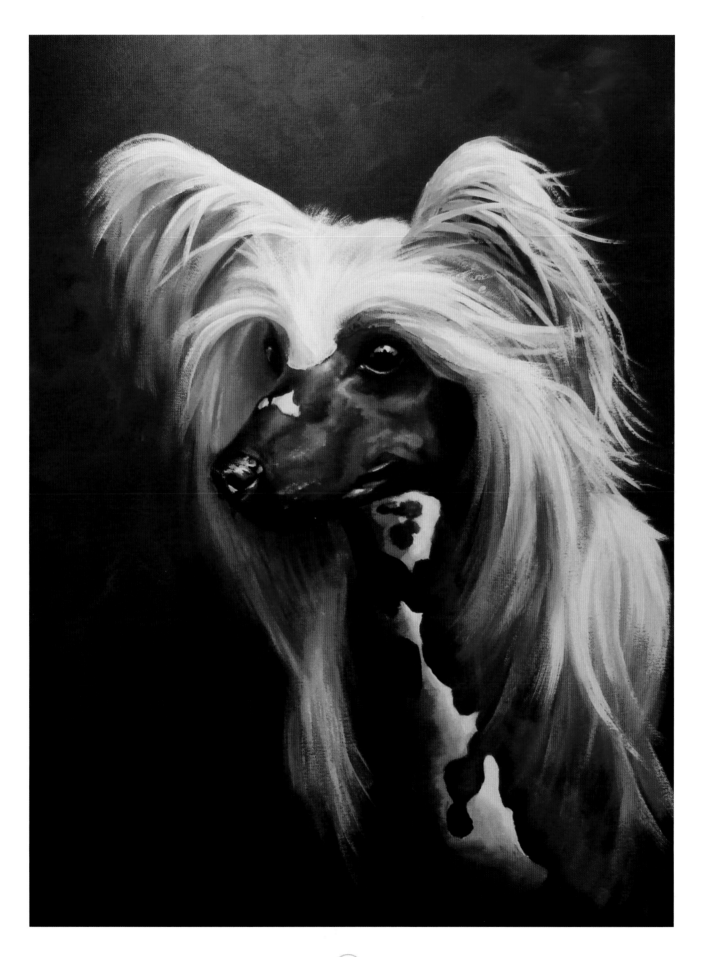

TECHNIQUES FOR SHORT HAIR

These are some of the techniques used to create short hair for the Alfie project, shown on page 104.

1 The underpainting was created with areas of colour and tone, often blended with a finger to create the underlying form.

2 I then used a no. 8 rake and titanium white to create the texture of hair, with short brushstrokes, here on the lit area to the left of the head.

3 I changed to the shadow mix of white, ultramarine and cadmium red deep to create hair texture at the edge of shadowed areas.

4 I continued using the rake wherever the texture of hair needed to show, here on the white flash running up the dog's muzzle.

TIGHT HAIR

Tight-haired breeds like the English Bulldogs shown below require less underpainting because the top coat is so close to the colour underneath. The lack of long, flowing locks leads to the appearance of rolls of flesh in the coat, especially in the stockier breeds. The underpainting should highlight the shadow areas in the rolls which appear in the neck and face when the head is turned. As the hair is so tight, the trick is to blend colours so that the rolls appear rounded. I find it easier in some cases to apply the paint with a brush, then blend with my fingers. This requires the two different tones of colour to be laid alongside each other on the painting and then blended into one another using a small or large finger. In larger paintings, using a small rake brush can create a blend, while also giving the impression of short hair.

DAISY, IZZY AND BELLA – ENGLISH BULLDOGS
101.6 x 50.8cm (40 x 20in)

There is no long hair in evidence here, but you can see the rolls of flesh covered in tight hair.

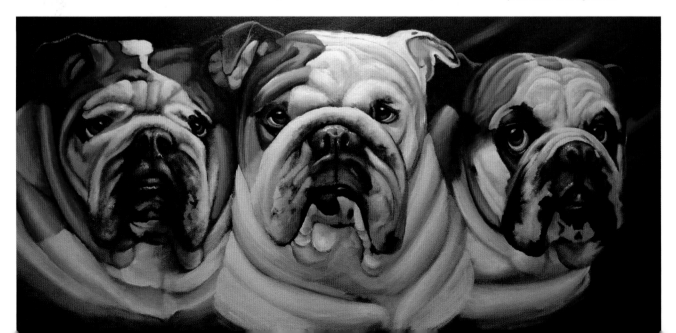

LONG HAIR

With the long-haired breeds, we can display fine, light hairs against dark underpainting and vice versa. Use various-sized riggers and the larger rakes to create long, fine lines of colour. By continually overlapping, we can give the impression of thicker hair, but this technique can disguise the fineness of the hair, so use it sparingly. The key to creating fine lines is the balance of water to paint in the mix. Too much of either will create a blob on the brush so that you can't create a line. Too little water will not allow the line to flow. Practise first.

OVERLAPPING BRUSHSTROKES WITH A RAKE

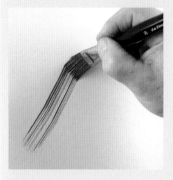
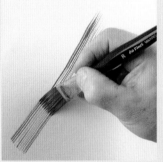
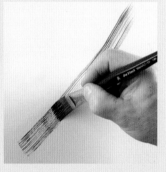
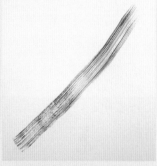

1 Begin with a red-brown mix and paint a smooth, even stroke. The rake's hairs separate to create the effect of hair.

2 Change to a browner mix and run this stroke into the first, overlapping and blending with the rake.

3 Change to a darker brown and run this final brush stroke into the middle one, overlapping the ends.

The hair effect created using the rake.

OVERLAPPING BRUSHSTROKES WITH A RIGGER

This was used for Kenzie's ear in the Demelza and Kenzie project (page 118).

1 Use a no. 4 rigger and paint locks of hair with burnt umber. Press harder to make the locks wider and graduate to thin at the ends.

2 Blend the edges of the locks of hair with your finger.

3 Continue, painting finer lines and suggesting the contours of the locks of hair. Add white to the mix for the parts that curve towards us.

4 Make the mix lighter still to paint the brightest highlights where the hair curves outwards and catches the light.

The key to making long hair look part of the dog is to blend the end nearest to the root into the colour of the underpainting, and again this can be achieved by using a finger, sometimes with a bit of water applied. This also works well for whiskers.

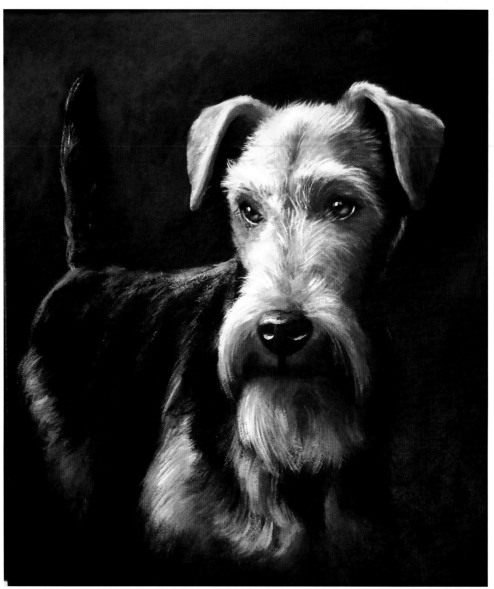

RUPERT – WELSH TERRIER
50.8 x 40.6cm (20 x 16in)

I painted Rupert twice: once when I first met him, before he had his Crufts show coat, and then again afterwards. The owners loved this version, so I still have the show version as display stock (see page 137).

Opposite
HARRY, THANE AND RICO – RED & WHITE SETTERS
101.6 x 76.2cm (40 x 30in)

Layering the chest hair adds to the feeling of three dimensions and makes the viewers feel that they can put their fingers into the hair.

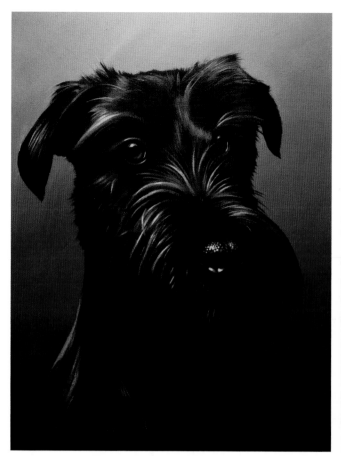

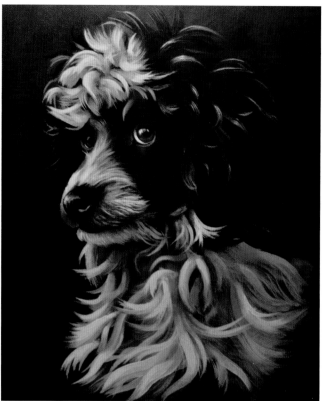

WOODY – GERMAN SCHNAUZER
61 x 45.7cm (24 x 18in)

Here a warm, vertically lit background goes with the lighting of the painting and showcases Woody's springy, reflective dark hair.

LUCY – PARTI POODLE
50.8 x 40.6cm (20 x 16in)

Black and white long hair which curls dominates this poodle's coat.

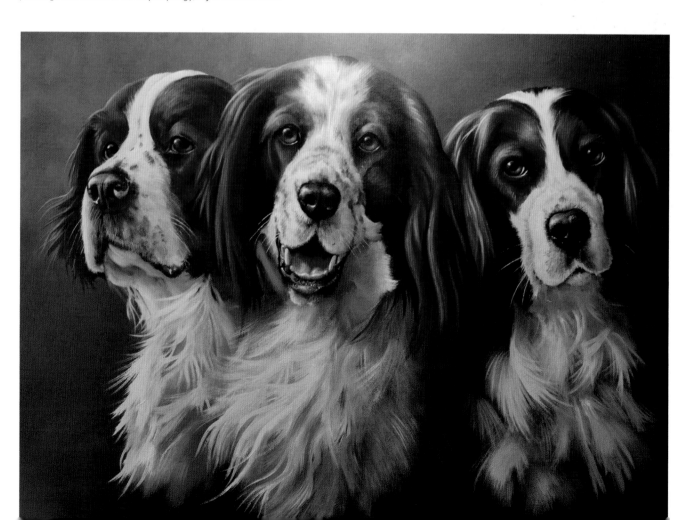

TRUE TALES

The dogs shown below were owned by a police dog handler and some had passed away before we did the commission. Dobermen's fur is so tight to the skin that it reveals a whole variety of contours in the head and body which essentially become the features that the artist is seeking. The key to the successful commission is to blend these contours so that they start and finish seamlessly within the main fur colour, creating a natural look.

The dog handler wrote to me: 'My dogs are my family/children/best friends, there when you need someone to love you no matter what. Whether good day or bad, loving you unconditionally, making you feel you are loved. I see the painting every day and it reminds me of the good days and sad days, as some of the dogs are no longer with me, but always in my heart. Everyone who has seen the painting instantly recognizes them as the dogs we had and those we still have.'

SEREN, COMET AND HALEY – DOBERMAN
91.4 x 61cm (36 x 24in)

These dogs have really short hair that is very tight to the skin. The artist's challenge is to create the tonal changes that suggest the contours of the head and body and the texture of the coat.

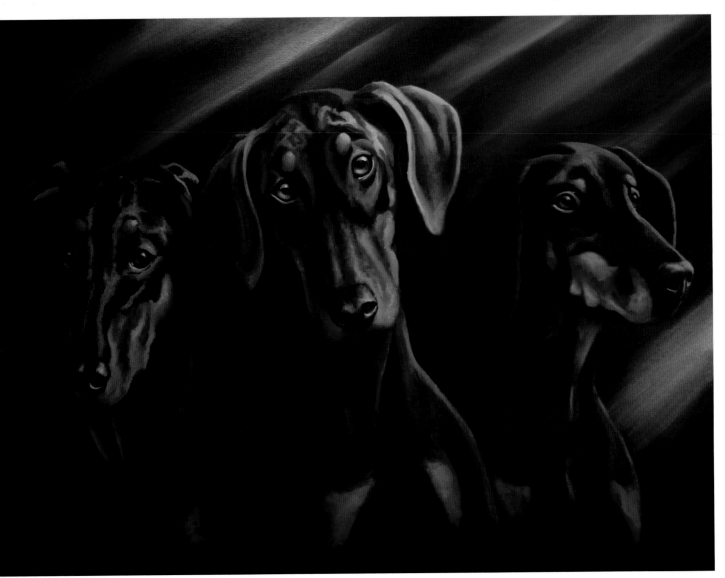

50

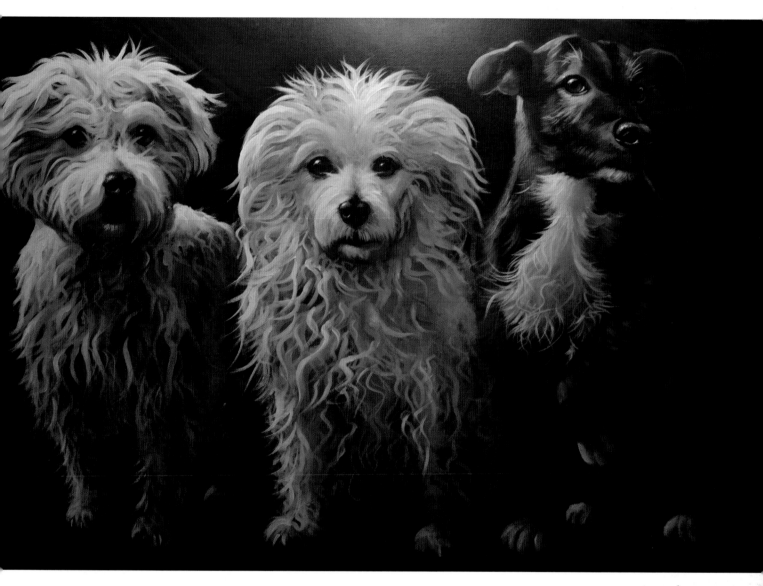

These dogs are owned by the current managers of the Stanwell House Hotel in Lymington in the New Forest. The painting is an example of how the rigger can create the image of bedraggled fur in the dogs on the left and in the middle. Alongside them is a short-haired terrier. For this one, I used plenty of colour in the underpainting and then lots of painstaking rigger work on top.

DUDE, LOLA AND LOUIS – TERRIER CROSS
91.4 x 61cm (36 x 24in)

These three had lots of straggly hair, so I started with dark underpainting and then layered on various tones of curled hair before painting the lighter top coat.

NOSES

A dog's brain is said to be a tenth of the size of a human's, and yet the part that controls the sense of smell is forty times larger. Humans tend to hear first, then see, then smell, while a dog smells, sees and then hears. We read emails and sometimes have to 'read between the lines', but dogs get the full story from 'pee-mails' and other smells!

We are aware of the dog's sense of smell from the more obvious fact that they point their noses in the direction of a smell, to the use of dogs for searching and detecting drugs, explosives and even serious illnesses such as cancer.

When it comes to painting, the nose is very important. If the portrait is facing towards you the nose is the nearest thing to you, and to give a sense of three dimensions it has to be the most distinct and detailed feature that you paint.

There are some distinguishing features of a nose that the artist needs to be aware of. Smooth, black, shiny noses are interesting to paint because you get a lot more reflective colours in them, but when they are dry and with lots of cracks and 'bobbles', they become more difficult. Sometimes you see an abnormality such as a pigment change and the owner might want you to show it by changing the direction of the face.

**PIP AND POPPY –
WORKING COCKER
SPANIELS**
76.2 x 50.8cm (30 x 20in)

Two working cockers with similar hair colouring but different coloured noses.

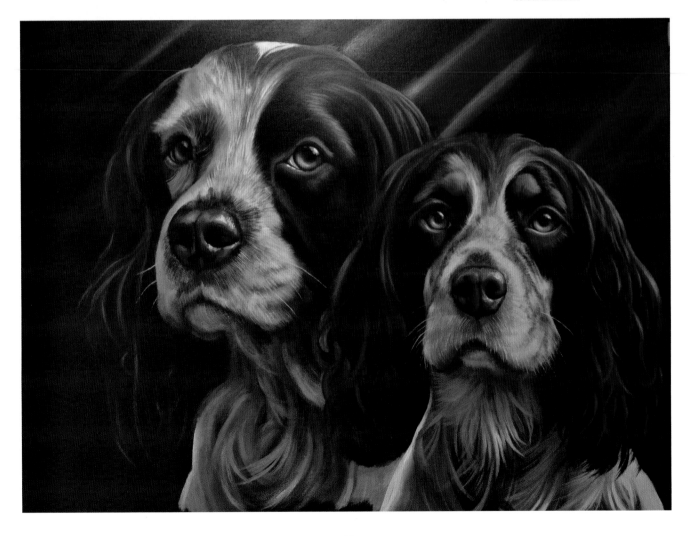

For a black nose, I would normally use a mix of ultramarine with Mars black, which softens the intensity of the black.

For a red nose, I use Venetian red, which is a brick red. This is usually very intense and opaque, so you don't need much of it. I normally mix ultramarine with this to create shadows in the nose.

For a brown nose, I would use burnt umber and mix in ultramarine to create either darker brown noses or the shadows within them.

After underpainting in the above colours, I allow the nose to dry, then add highlights in lighter colours to create the surface texture. Sometimes this is smooth, creating a reflective surface, but often the underpainting represents the cracks in the nose, so I use various shapes of lighter colour to suggest the surface, leaving the darker underpainting to show between them.

BEAR OR BRYN DU – GERMAN SHEPHERD
61 x 45.7cm (24 x 18in)

The background was designed to go with the customer's favourite colour, which was in the curtains. Bear's coat was highly reflective but was also a red-black, so allowed me to include his tongue because the colour went with both the background and his coat. The final touch was to reflect a warm blue in Bear's nose which complemented all the other colours.

- *About the nose*

- **The colour** Is it a black, red or brown nose?
- **The form** Is there a distinctive shape like a heart and is there a visible split in the middle? Does it stop where the muzzle starts or blend into the face?
- **The surface** Is it shiny and wet or textured and dry?
- And finally, does it have any abnormality in any of the above?

SABRE – GERMAN SHEPHERD CROSS
61 x 45.7cm (24 x 18in)

Sabre's nose was always wet from continuous licking, so it was highly reflective and contained very little of its own colour – just reflections of the colours around it.

PAINTING A NOSE

This is Demelza's nose from the Demelza and Kenzie project on page 118.

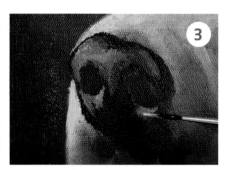

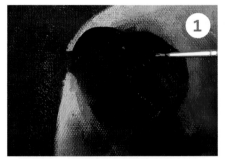

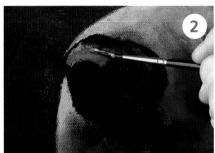

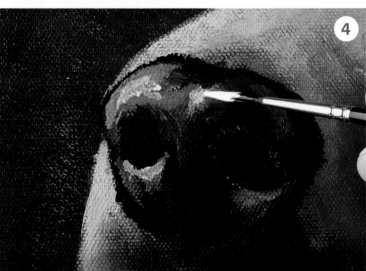

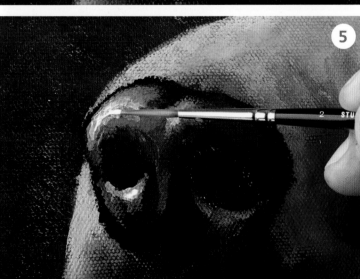

1 Mix ultramarine and burnt sienna to make a black for the nose, which should be more blue than brown. Flood the area with a no. 2 rigger.

2 Add a touch of this mix to white and paint in the lighter parts of the nose. With just water on the brush, blend the light mix into the dark background to create a rounded effect.

3 Continue painting the lighter parts of the nose where the light catches it below the left-hand nostril and at the bottom corner of the right-hand nostril. Blend in the edges as before.

4 Paint on titanium white highlights above and below the left-hand nostril and above the centre. Blend the edges a little into the wet paint.

5 Use the tip of the rigger to paint the smallest, sharpest highlights and blend a little. This should create the sparkling effect of a wet nose.

EARS

A dog's ears have three times as many muscles controlling them than a human's! Those dogs which have upright ears, not surprisingly, tend to hear better than those with droopy ears. A dog's sense of hearing is heightened by the fact that they can detect higher-pitched sounds at something like 45 kHz, while a human's hearing operates up to 23 kHz. This has led rise to the invention of the seemingly silent dog whistle, which most humans can't hear.

You will usually need to paint two types of ear: the upright and the droopy.

UPRIGHT

In painting the upright ear particularly, there is an opportunity to introduce a different colour to the normal dog hair colours: pink (see the painting of Jess, opposite). Depending on the thickness of the ear, this colour can be intensified by light coming through the ear and highlighting it. This is always a help to the artist when you want to depict the portrait with a tongue protruding from the mouth as it allows you to include pink in another part of the portrait and so bring a balance to the image, rather than having an isolated colour.

The hair you paint in or around the ear is sometimes minimal, just on the outside of the front edge, and you often have to paint thin and wispy hair inside the ear. The mobility of a dog's ears also allows the artist to turn them in different directions.

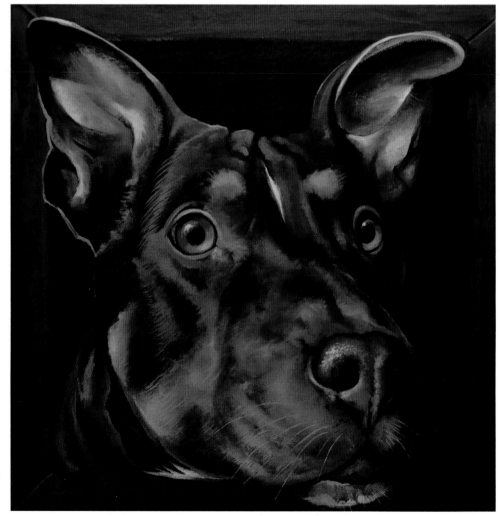

THAI – STAFFORDSHIRE
BULL TERRIER
50.8 x 50.8cm (20 x 20in)

The canvas requirement was a square but Thai's upright ears needed to be included, so to minimize the amount of background and increase Thai's size, I created an artificial frame in the painting.

DROOPY

With the droopy-eared dog, you don't normally get the chance to paint inside the ear, since you can only see the outside. Depending on the breed, you usually need to paint either tight, short hair like a Poodle or the luxurious, flowing hair of a Springer.

For short-haired ears use round brushes, and for those with slightly longer short hair, you can use a small rake to finish. For the longer hair on droopy-eared dogs such as Springers, I recommend the use of various length riggers.

The hair on Springer Spaniels often has a waxy appearance and is therefore reflective, so I graduate to a lighter colour where the hair bends towards the light.

JESSICA – BLACK & TAN CAVALIER KING CHARLES SPANIEL

50.8 x 40.6cm (20 x 16in)

The hair on Cavaliers' ears can gather together in locks, giving it a waxed look. It is highly reflective.

This is Yolo, a Pomchi (a teacup Chihuahua crossed with a Pomeranian). Her owner asked if I could paint her on a large square canvas, and of course I said 'yes', but the sizes I quoted were too small for her. I suggested that since Yolo was a small dog, maybe the smaller canvas was more appropriate, to which she replied, 'You're going to need a bigger canvas – you should see my wall!'

It turned out the owner was an interior designer and had ripped out the ceilings from her modern bungalow to create an enormous wall. A small canvas would have been lost there.

I painted Yolo on a large 80 x 80cm (31½ x 31½in) canvas with the light from the left. I took the painting round and it fitted perfectly. The owner burst into tears, said it was beautiful, looked at the wall opposite and said, 'Could you do another one the same size to go on that wall, with a different look?'

The key decision when painting dogs with upright ears on a square canvas is whether to include the ears. If you do, you have the dog looking out from within the painting, which will include background. Alternatively, you can fill the canvas with the face and exclude the ears, so that the image 'invades' the room. If you choose this method, there will be no background showing.

For this painting of Yolo, I decided the dog needed to invade the room… as they say, small dog, big character!

YOLO – POMCHI
80 x 80cm (31½ x 31½in)

EYES

This is the part of painting dogs that most artists want to do first. The eyes are usually the smallest thing in the painting and the first thing that your viewer will look at. They have to be right. However, it's no good painting the eyes if the rest of the dog is out of proportion, or the wrong colour, so I recommend you get everything else right first. There is so much fine detail in the eyes, and if you do them first the rest of the dog has to follow in the same style. First establish the position of the body and the 'look', for instance joyous, coy or contemplative, and then you can use the position of the eyes to accentuate that look.

As with human eyes, light enters through the cornea and the pupil, which expands and contracts to control the amount entering. It then passes through the lens and hits the retina, where it is processed.

Sometimes there is very little colour in a dog's eyes, for example a Westie often has what is described as black button eyes. If you do see colour, as with Lily here (also shown on page 32), it is worth considering overemphasising it to provide a focus in the painting.

The position of the pupil within the iris directs where the eye is looking, so it is important to capture this accurately in both eyes. If one pupil is looking one way and the other is positioned differently, the eyes will look wrong. If the pupil is inside left in the right iris and inside right in the left, the dog will look cross-eyed!

In a dog's eye, the light shows in the opposite side of the iris from the light direction. If the light comes from top right, it will make the iris shine brighter at bottom left. At the same time, the cornea is a reflector of light and will reflect not only an image of the surroundings, but also the source and colour of light. Human eyes do the same, so observe this effect when you are cleaning your teeth!

Once you have established the eye shape by creating the upper and lower eyelids, you need to paint the background colour – the darkness of the shadow around the lids and the pupil. This may already be in place if you have painted a dark background, so you can progress to the darker base colour of the iris. In a brown eye, use burnt umber to establish the size and shape of the iris. Make sure you don't paint over the background colour of the pupil. Once the pupils are looking where you want the eyes to look and the paint is dry, lighten the lit side of the iris and blend that into the darker colour.

While that iris is drying, paint the reflection of the light hitting the cornea. I start with the colour of the sky, for example a light blue, but not the brightest colour at this stage. The outside edge of this reflection has to follow the shape of the upper eyelid, as this casts a shadow underneath it. If you don't follow this shape, the reflection will not look as if it belongs in the eye.

Next return to the iris, which should be dry now. Glaze the predominant top colour over the blended base colour of the iris to create depth. In this way you use the transparent properties of acrylics so that any change of light on the painting will be exaggerated in the eyes.

Finally, place a pinprick of light in the dried sky-blue reflection on the cornea using a very fine brush such as a rigger. I try to match the upper outside edge to the shape of the reflection. This can be tricky using such small brushes, so you may have rub off your first attempt and try again.

If you paint a dog on a small canvas, this level of fine detail becomes nearly impossible. The larger the facial image, the easier it is to depict the eyes.

ENGLISH SPRINGER SPANIEL
61 x 61cm (24 x 24in)

One of the problems of just doing commissions is that all your work is hanging on someone's wall and you don't have enough examples of what you do. So this Springer was an amalgamation of five dogs I had painted for various people: the ears of one, the eyes of another, nose of another and so on. The eyes were selected as the most artistic and I think they give the painting its appeal. However, whenever a breeder or dog show judge sees the painting they turn away because the eyes are 'not breed standard'! Some people see things differently to the artist!

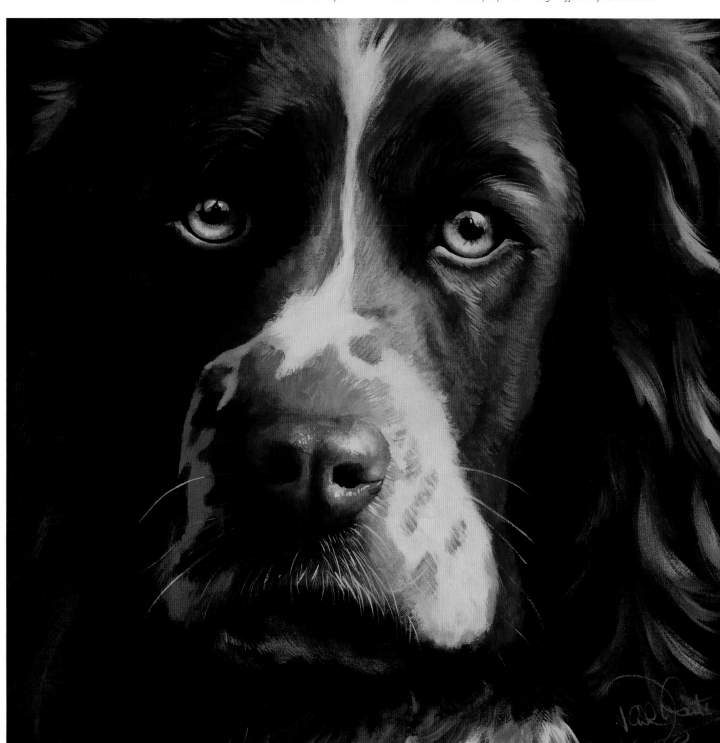

HOW TO CHECK IF THE EYES ARE RIGHT

Things can go wrong when painting eyes. Sometimes you stand back and think, 'that's not right', but you can't immediately say why. A good test is to move to the right then the left and check whether both eyes follow you. It could be that one does and the other doesn't, which means that something is wrong. Then check:

· Are the eyelids and sockets out of alignment – is one higher than the other? Is the angle of one different from the other? Is the internal socket of one larger or smaller than the other?

· Are the pupils the same size and shape? Are they pointing the same way?

· Is the width of the iris the same for both eyes? If not, one will need to change.

· Is the angle of the reflection the same in both eyes? For example, are both at 2 o'clock or is one at 1 o'clock? Is the angle of this reflection the same as the angle of light on the coat? If not, change the angle in the eye to that on the coat, which saves time and work.

· The eye nearest the light should be slightly brighter in the iris and the reflection compared with the eye which is further away from the light.

The beauty of acrylics is that if the painting is not right, you can just paint over it and start again within a few minutes. This can be very helpful when painting the eyes. If things have not worked out, go back to the lifeless socket stage and begin the process again.

WOODY – COLLIE
61 x 45.7cm (24 x 18in)

I chose to make the light reflection on Woody's hair match his eyes so that the eye colour didn't look isolated in the painting.

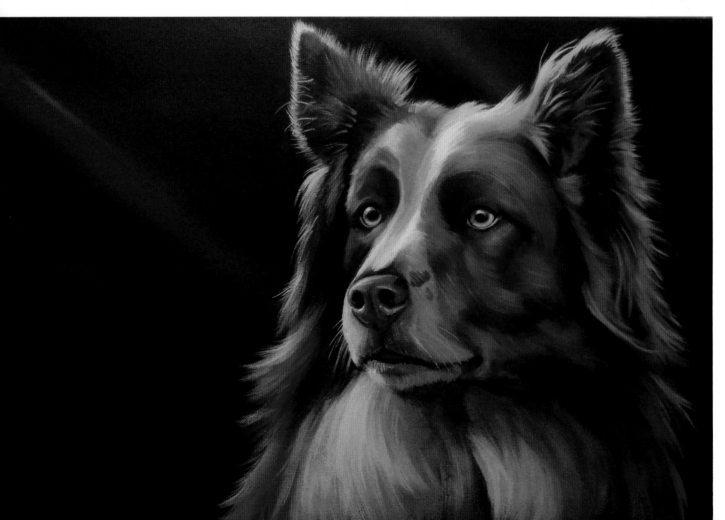

EYE TIPS

- Do make sure your overall image is large enough to paint the tiny eye details.

- Do make sure that the shape of the eyelids is correct before you paint the irises. If they are looking in the right direction and are balanced, even as black holes, continue.

- Do leave a fine, shadowed gap between the upper and lower edges of the iris and the eyelid. This sets the iris apart and gives it depth.

- Do consider the shapes of reflections on the cornea: they are not just circles but reflect the environment. The edges are usually slightly rounded.

- Do take your time over the eyes; they are the focus of the painting.

- Don't paint reflections created by camera flashes.

- Don't paint the whole iris or the dog will look mad!

- Don't overcomplicate – as they say, keep it simple, stupid!

HETEROCHROMIA

One fascinating and beautiful phenomenon is when one or both eyes is missing pigment in the iris, turning it a light blue or green. This is called heterochromia and it can either be full, where both eyes lack pigment; partial, where only one eye is affected; or sectoral, where part of one or both irises is missing pigment. You often see the phenomenon in Border Collies but it is not limited to them. Such eyes are very distinctive and can add complications to the painting. However, stick to the above principles and you will be able to depict even unusual eyes accurately.

WILSON AND SPIRIT –
BORDER COLLIES
71 x 45.7cm (28 x 18in)

Spirit's left eye shows heterochromia.

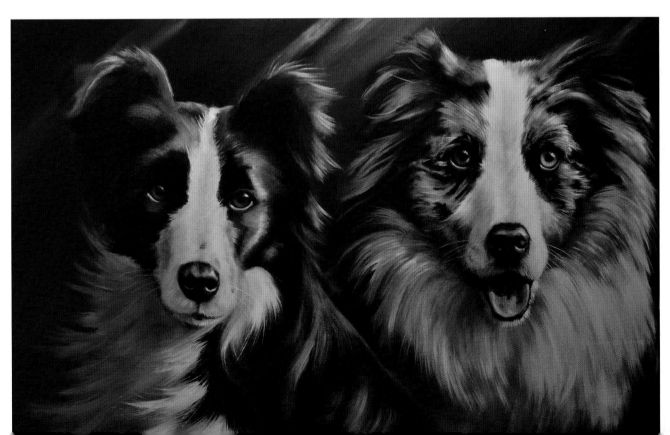

TURNING THE LOOK TO CHANGE THE MOOD

There are times when you need to change the direction in which a dog is looking in a painting, making it different from any photographs you have. For instance, you might want to point the face towards where people sit in a room or even make it look out of the window. Alternatively, you might want to vary the direction of gaze of each dog in a painting featuring multiple dogs, just to make sure you have variety. This can involve tilting one dog's head to one side or turning it in a slightly different direction from any of the others, as shown in the painting below.

THE COMPLETE SET – SETTERS
91.4 x 61cm (36 x 24in)

With a number of similar-shaped dogs, it is important to vary the direction in which the dogs are looking. Here I based the direction of the dogs' faces on four different points on the circumference of a circle to achieve that variety.

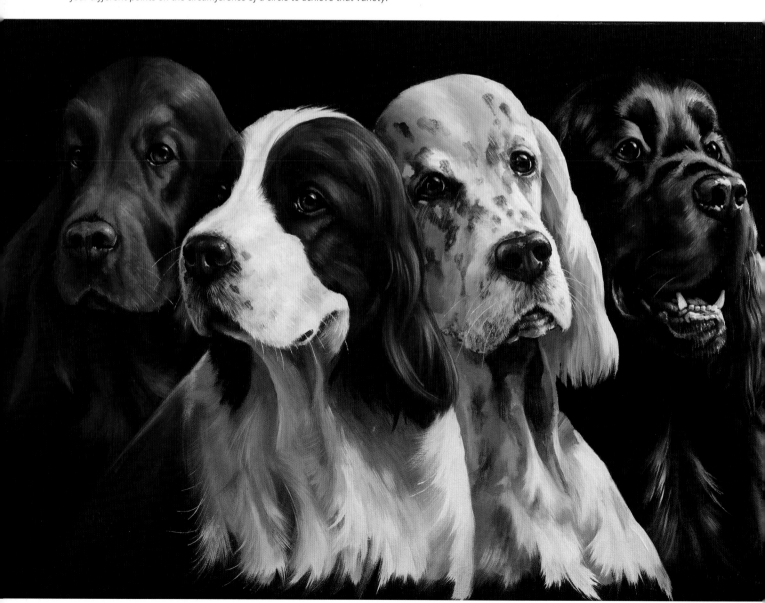

It is good to establish with the owners where they want the dogs to be looking, even if the eyes are not totally visible! The client for this painting of Sealyham Terriers, Lizzie and Flora, commented, 'Wherever you sit in the room, she is looking at us, like the Mona Lisa, and the other is looking out of the window as she loves to do. We have only the one dog now, and to sit and look at the painting brings back lovely memories of her as well as her funny little ears and sweet expression. Those who have seen it have commented on how lovely it is and how well the character of each, very different from each other, has been captured.'

LIZZIE AND FLORA –
SEALYHAM TERRIERS
61 x 45.7cm (24 x 18in)

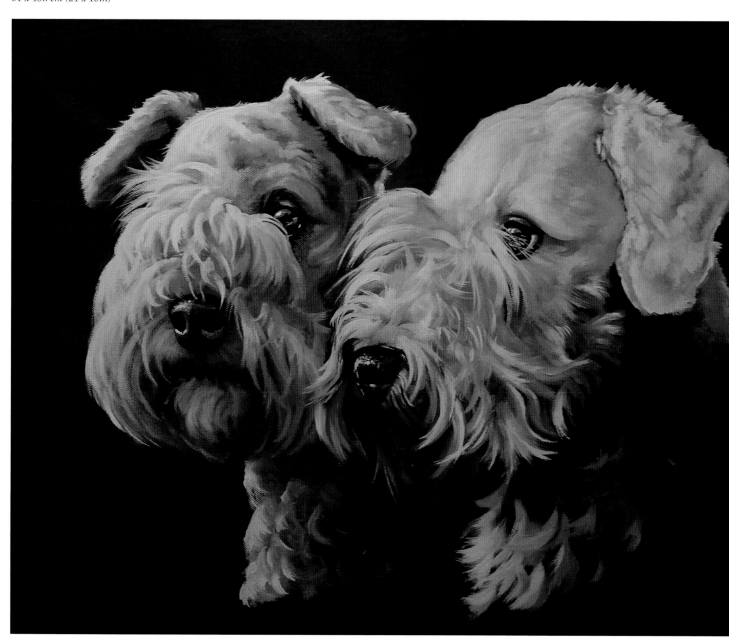

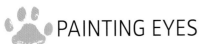

PAINTING EYES

Here I show you how to paint the eyes of my own dog, Alfie.
The project is on page 104.

1 Use a rigger and burnt umber to paint the iris, leaving a negative space for the pupil. Add white at the bottom right, since dogs' irises light up in the part opposite to the direction of light. Wet the end of the brush and blend. Allow to dry. Paint the other eye in the same way, adjusting the pupil shapes so they match.

2 Paint half-moons for the whites of the eyes with titanium white and ultramarine. The shape is vital, but don't worry if you don't get it right first time. Add more blue in the white of the right-hand eye.

3 When the irises are drying and tacky, brighten them with a little burnt umber and titanium white, then blend smoothly with a wet brush and allow to dry.

4 Paint a reflection on the pupil with ultramarine and titanium white, making a quarter circle in the top-left quartile, following the line of the eye socket.

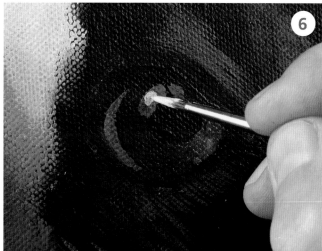

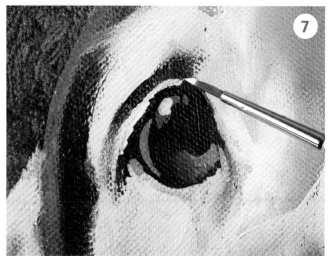

5 Repeat in the right-hand pupil, this time adding a little broken off bit, leaving a dark line in between.

6 Paint a tiny white highlight in each eye. The one on the left should be slightly bigger; the one on the right is the smallest thing in the painting. The outside edge must follow the shape of the eye socket.

7 Stand back and check the eyes. Now is the time to adjust anything that isn't working (see page 62). I adjusted the shape of the left-hand eye socket with titanium white. If the pupils are not the same shape, the eyes will not appear to work together, so I adjusted the shape of the left-hand one to match the other, using the iris colour. Allow to dry.

8 Make a glaze from Winsor & Newton burnt sienna with a tiny amount of water, to create a waxy finish (see the palette, inset). Glaze this over the irises, overlapping into the black pupils. Adjust and reshape the eyes as necessary.

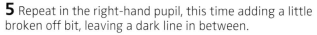
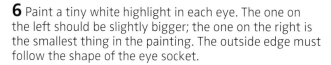

The transparent mix for the glaze.

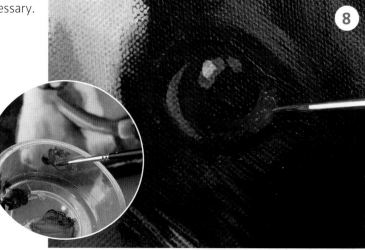

The finished eyes.

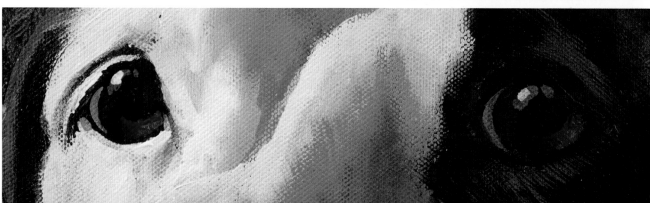

WHISKERS

Whiskers are not the same as the dog's hair because they are more innervated (or connected to nerves). They allow the dog to experience its environment in a focused way, and they not only receive signals but also transmit them, for instance pointing forward if the dog feels threatened.

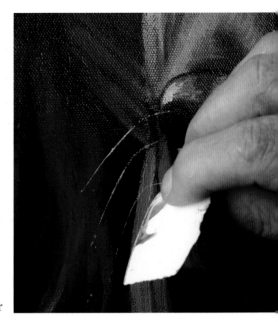

I have known dogs to have very short whiskers, so that they don't look like they have any, while others have many very long ones, not only around the muzzle but also above the eyes and on the chin. For single-colour dogs like Labradors, it is worth counting the whiskers on both sides of the muzzle, because there is often an imbalance in number and placement, which adds interest to the painting. There are often colour differences, ranging from light to dark black whiskers.

It is very hard to make a brushstroke depicting the fineness and length of a whisker. My solution is to print them instead by painting the edge of a piece of card and then applying the paint to the point where the whisker emerges from the face. This is not always accurate, so you need to have a wet cloth available to wipe off the paint which goes beyond that point. However, when correctly done, this technique is incredibly effective.

WHISKER TIPS

- The face needs to be finished, dry and accepted by the owner before you apply whiskers. Any later change will make any whisker work redundant.

- If the background paint is thick and uneven, painting or printing a fine line will be impossible, which is why I tend to paint smooth backgrounds.

- The volume of water to paint in the mix applied to the card edge must be right. Too wet and the paint will blob and diffuse on the painting surface; too dry and the line will be uneven, with gaps. Try out the consistency on spare paper, then if it works, recharge the card with paint and apply to the painting.

- If the card isn't fine enough, try different thicknesses such as a postcard or magazine cover. I have offcuts from my 300gsm (140lb) prints which create an excellent finish to a whisker. The beauty of using card is that you can bend or angle it but you always get the same thickness of line.

- The card faces you when you apply paint to it, but you will turn it to print on the painting, so remember that the left of the card becomes the right side of the painting. If you want the whisker to be finer to the right, apply the paint to the card with a brush, moving from right to left so it runs out towards the left. When you turn the card over to print, the whisker will be finer on the right.

- Sometimes the paint doesn't thin out sufficiently due to the paint/water mix. Let the painted whisker dry partially, then gently wipe a wet cloth along the line, thinning the paint and lengthening the whisker.

- When you have found the correct thickness of card, you can also paint a light reflection within the thickness of the whisker – the advanced technique!

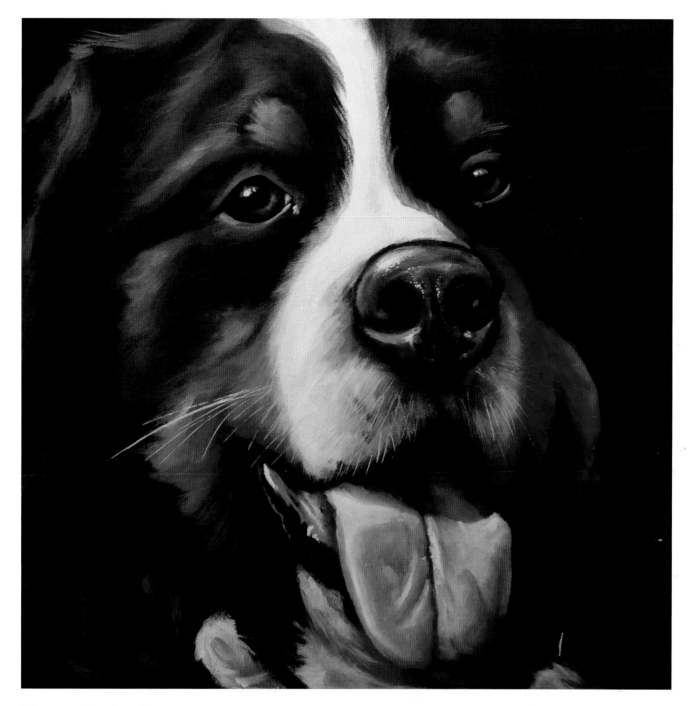

TOBY – BERNESE MOUNTAIN DOG
50.8 x 50.8cm (20 x 20in)

To make the whiskers appear three-dimensional, use two tones of colour: one for the dominant whiskers and another for the smaller and less important ones.

TONGUES

There are many quotes about the tongue and what we should and should not do with it, and it raises one of the questions I ask my commissioner: tongue in or out?

Dogs use their tongues for food tasting, drinking or a drippy wet greeting, and as a radiator, healing instrument and salt-licking tool – especially off my balding head! Whether or not the tongue is often on show can be part of a dog's character, so it is important to establish whether to show it or not.

Sometimes there will be black markings on the tongue which can effectively act as a fingerprint. Sometimes the shape is distinctive, but the most convincing argument to show a dog's tongue is to make it 'smile' in the painting! If someone smiles at you, it is very difficult to not smile back, so by showing a dog's tongue, you invite a happy response from the viewer.

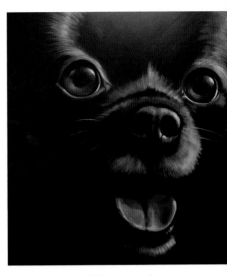

YOLO – POMCHI
80 x 80cm (31½ x 31½in)

This is the second version of Yolo, painted to go on the opposite wall to the original (pages 58–59). It is the same size but has the lighting reversed. It also shows how having the tongue out changes the dog's expression.

GHILLIE, KILTIE AND KISMET – GORDON SETTERS
91.4 x 61cm (36 x 24in)

Here all three dogs have their tongues out, which gives the painting a lively, cheerful feel.

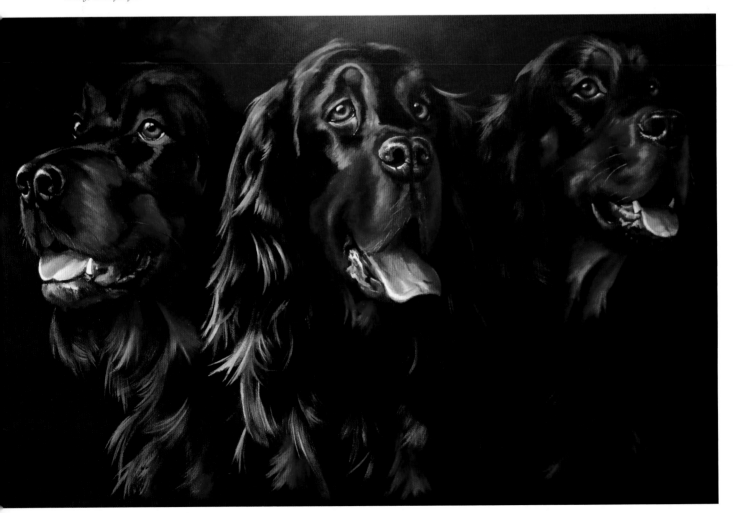

TONGUE TIPS

- Be careful of the colour: a dark, purply red suggests an exhausted dog. Check the colour when the dog is at rest.

- The length of the tongue can make the dog look ugly; shorten it where possible.

- Having the mouth open may show the teeth as well, and this can make the dog look aggressive. Hide the teeth under the tongue to soften the image.

- Check whether the tongue has a split down the middle or not.

- Add highlights if you want to make the tongue look wet.

- The tongue introduces an isolated colour, pink, into the painting. Look for opportunities to balance it with the same or a sympathetic colour – in raised ears, the background, a collar or another dog showing its tongue.

HAMISH, IZZY AND BARKLI – NEWFOUNDLANDS
101.6 x 76.2cm (40 x 30in)

These Newfoundlands have their mouths open to varying degrees to show 'smiles' but not excessive lengths of tongue, apart from Hamish, who is showing off a spot on his tongue.

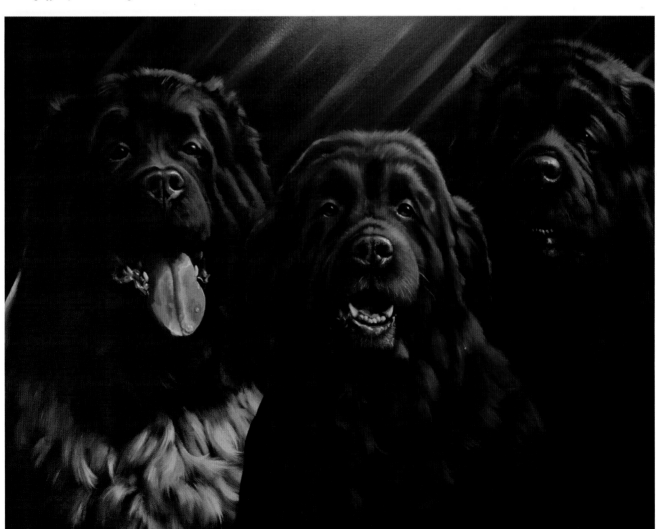

CREATING DEPTH

When I asked a client, Fiona, about her dog Dennis, she said he was inquisitive. The painting couldn't be very big as there was only a small wall space, so I painted the image of a frame on the canvas and made it look like distressed wood using crackle paste. Then I painted Dennis over the frame, which brought him forward and created the inquisitive look.

Giving an animal portrait a setting (in this case a frame) creates an artificial depth, bringing the animal forwards and setting the painting apart from two-dimensional photographs.

Adding shadows gives further depth, as in the painting of Nico, where the large right-hand ear creates its own shadow across the head.

The more you enhance the projection of the features and add shadow, the more an image will appear three-dimensional. First, give depth to the background by shadowing it using graduation techniques. Moving on to the portrait, you could even blur out the body so that the head projects. Graduate the head, changing the tone from dark to light so that it appears more rounded. You can also create this impression by painting the part which is further away with less detail than the part closer to the viewer. When you paint an ear, graduate inside it and then add shadow both inside and out. Continue in the same way with all the features so that each part becomes a three-dimensional project in its own right.

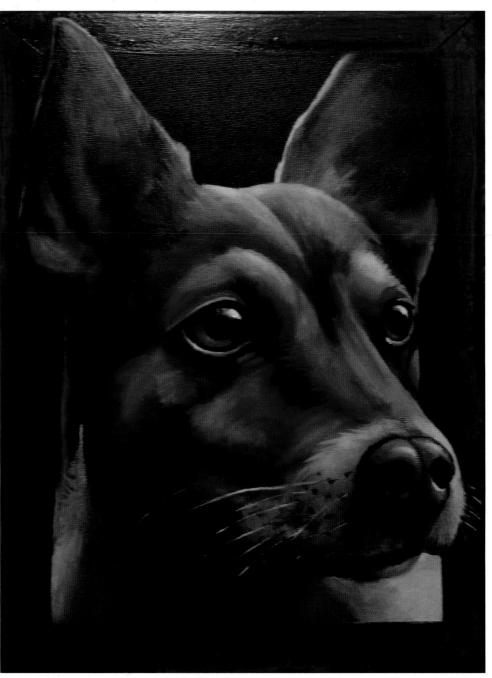

DENNIS – CROSS
50.8 x 40.6cm (20 x 16in)

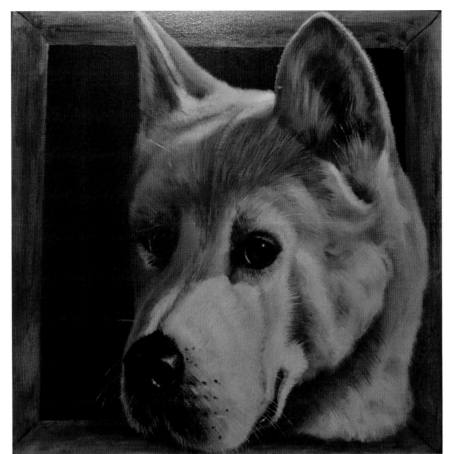

NICO – INUIT
50.8 x 50.8cm
(20 x 20in)

Nico's portrait uses many different elements to make her look three-dimensional: the artificial frame, the shadows cast forwards and the heavy graduation of the main features.

JAKE – BROWN LABRADOR
61 x 45.7cm
(24 x 18in)

In Jake's portrait I have added a blurring to the body on the left of the painting to bring the rest forwards.

There are times when we might want to broaden the setting and give the painting a finite depth. The painting below captures a real place for an annual holiday, and the owner wanted all three of her Poodles (one Miniature and two Parti) leaping over the groyne. It was virtually impossible to photograph all three leaping at the same time, so I used separate reference photographs. However, in the painting, each dog has its own shadows and then additional cast shadows on the surroundings, which gives depth to each image within the overall painting.

MILLY, SKY AND LUCY –
MINIATURE AND PARTI
POODLES
91.4 x 35.6cm (36 x 14in)

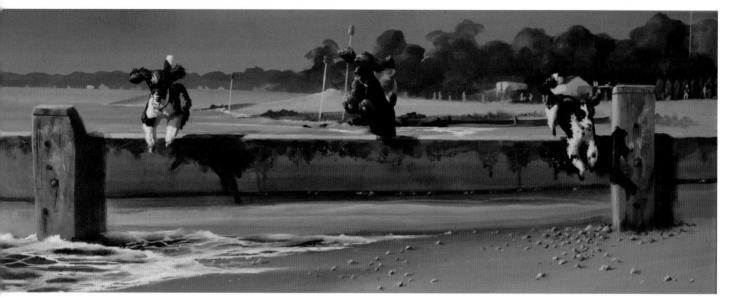

Another way of creating depth when there are multiple dogs is to layer them against each other. If you just place them side by side, the resulting image will look flat. But by selecting those who are more prominent, you can set some images back and promote others forward (see Painting Multiple Dogs, page 76).

TILLY, HOLLY AND PIPER
– ENGLISH BULLDOGS
101.6 x 76.2cm (40 x 30in)

This trio has been placed with Holly in the middle, coming forwards towards the viewer. This effect has been achieved through the use of lighter tone and warmer colour as well as the positioning of her paws.

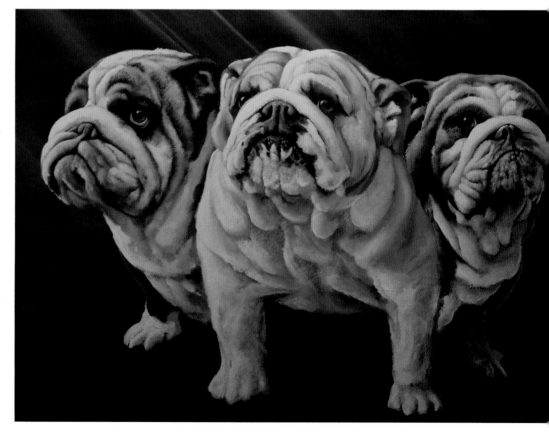

TRUE TALES

Chester the Westie always wanted to go to work with his owner, so he sat next to his briefcase every morning before he went to work. I therefore painted him in the briefcase and called him 'The Boss'. Looking for a good setting can create a story in the painting as well as giving depth to the image.

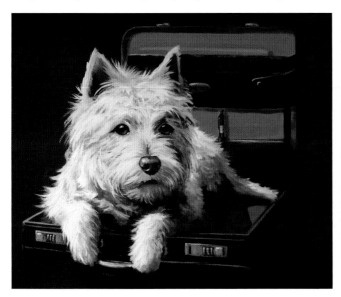

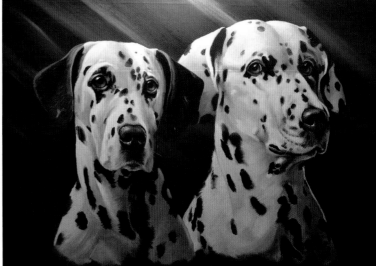

**'THE BOSS' CHESTER –
WEST HIGHLAND TERRIER**
(61 x 45.7cm (24 x 18in)

PRIMA DONNA AND MINNIE MOUSE – DALMATIANS
61 x 45.7cm (24 x 18in)

It is quite difficult to make a fur-coated dog look three-dimensional, because a photograph will often reduce the level of shadow, making the image look flat. By exaggerating the shadow, you will give the painting depth. These Dalmatians have had their shadowed areas deepened and coloured towards a purple bias to make the overall image more colourful and to add depth.

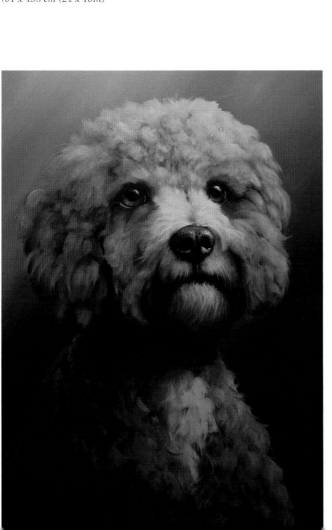

PIP – LABRADOODLE
61 x 45.7cm (24 x 18in)

The clients for this painting of Pip won the portrait at a church auction in which they were determined to outbid all comers to secure a likeness of their beloved pet. One of the owners commented: 'I love the painting because it reminds me of Pip as a younger dog. As he grows older, the vibrancy of his rich red coat is softening, but the twinkle in his eye and twitch of his nose remain. When I gaze at the painting, I'm reminded that although Pip's paws may not be quite as nimble as they once were, his bold spirit is as splendid as ever it was. The painting is a real talking point and people have said, "It's so three-dimensional – Pip's going to jump out any minute" and "It's so much better than any photo you have of him".' It goes to show that achieving depth in a painting is vital in order to create the impression of a living animal that will really appeal to the viewer.

PAINTING MULTIPLE DOGS

There is nothing more satisfying than producing a large, colourful painting of a family of recognisable dogs. It makes people smile as it brings back fond memories. There are three main issues to consider:

· *The size of the canvas to fit the wall and the number of animals.*

· *The relative sizes of the animals.*

· *The relationship between the animals (who should go next to whom).*

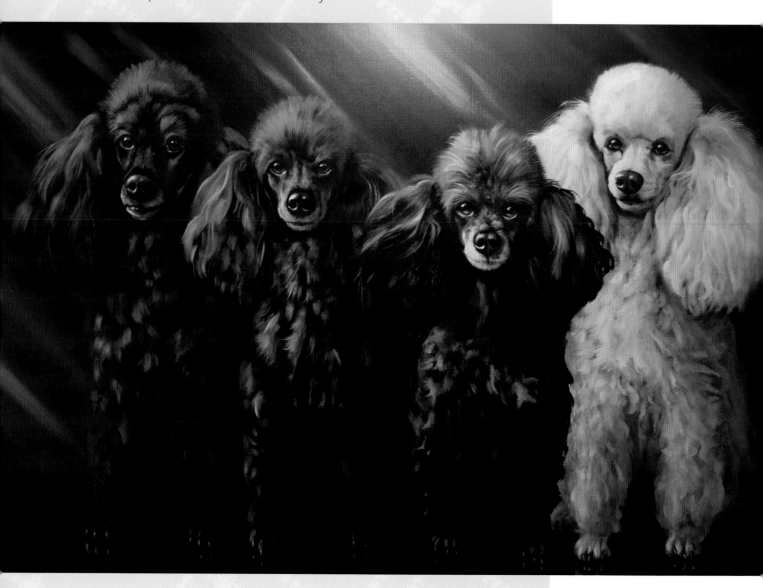

RUFUS, MUFFIN, LOTTIE AND MILLIE —
MINIATURE POODLES
91.4 x 61cm (36 x 24in)

It is inevitable that smaller dogs need to be further forward in the arrangement of a group, which means that they are often the last to be painted.

CANVAS SIZE

I check the wall the painting is going on to see the maximum size of canvas it will take. The bigger the support, the better – it gives you so many more options. However, bear in mind your limits: your easel and studio might not be able to take that size of canvas, so find a compromise.

EDDIE AND DAISY –
BASSET HOUNDS
61 x 45.7cm (24 x 18in)

*The length of the faces determined
the portrait aspect of this painting
even though there are two dogs.*

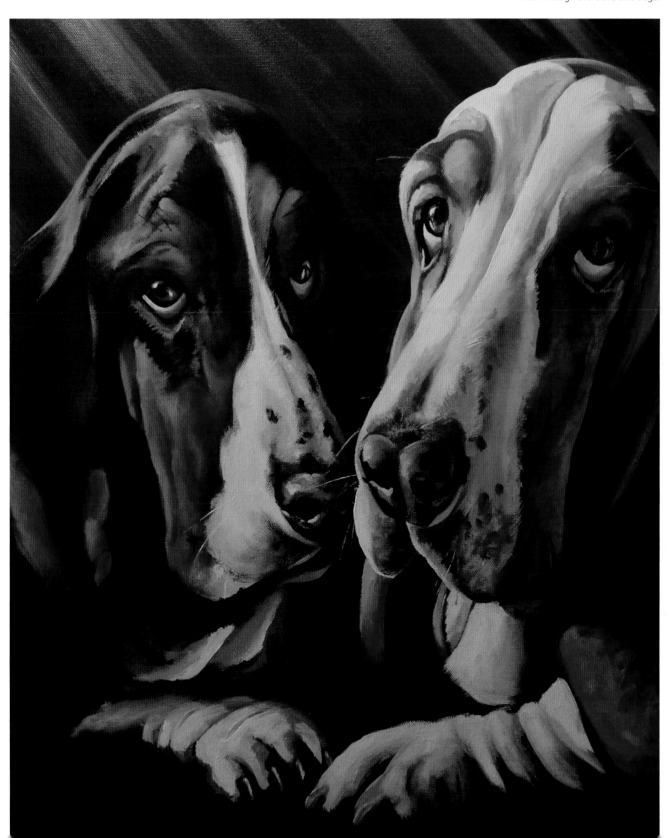

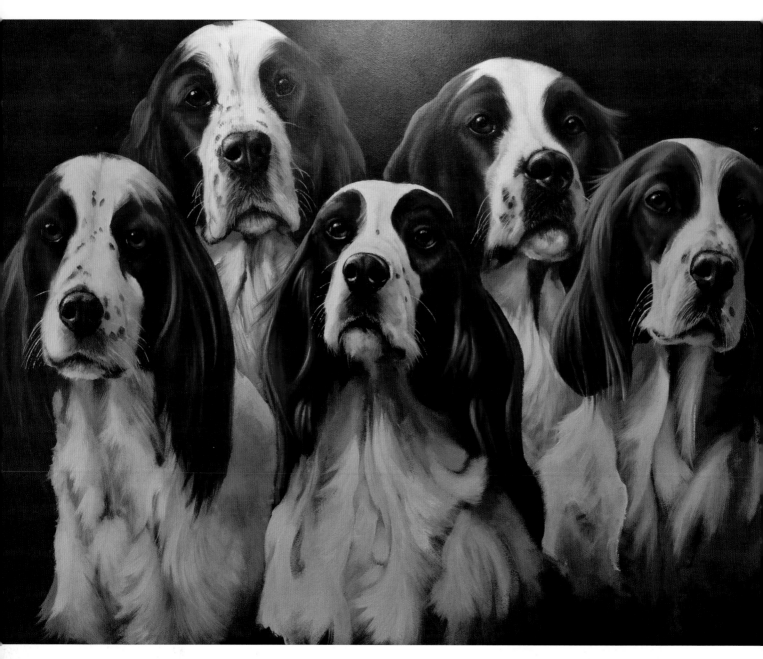

RELATIVE SIZES

Usually when you are including a mix of large and small animals in one painting, it is unlikely that you will be able to put the largest in front without pushing the smaller ones to the side. The depth of the canvas needs to cope with the tallest relative to the smallest animal. It is worthwhile being aware of how many times the smallest animal's height fits into the largest before selecting the canvas and assessing whether the size of the smallest will be reasonable.

DARLA, GILES, BREE, JASPER AND JANEY – RED & WHITE SETTERS
101.6 x 76.2cm (40 x 30in)

With a mix of genders, it is often the females who have to come to the front because they are slighter than the males.

RELATIONSHIPS

There are so many different types of relationship you can have within a painting of multiple animals: from parents and offspring, oldest to youngest, largest to smallest or those who do and don't get on. Accommodating these relationships can grate sometimes against artistic requirements, such as colour relationships, sizes and composition issues. At this point it becomes a huge advantage to be able to chalk out the outlines of the individuals so that you can play with their positioning.

JORDIE AND TED – BICHON SCHNAUZER AND LAKELAND TERRIER
61 x 45.7cm (24 x 18in)

Depicting a close relationship should be straightforward, but when the dogs are the same colour, you still need to separate them with a little shadowing.

In the painting below, from right to left: Ayrton was a multiple champion and the tallest, which I felt made him look rather aristocratic. Rory (second from right) was a nervous rescue dog who wouldn't look you in the eye. Next, Sophie behaved like a princess and poor Maddie, on the far left, kept dropping off to sleep when shown in the ring, so I tipped her head to one side!

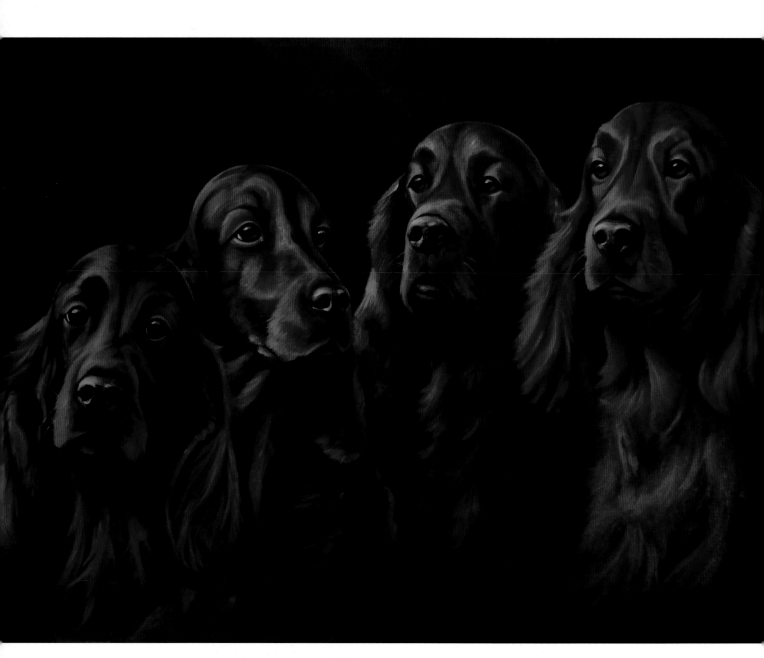

MADDIE, SOPHIE, RORY AND AYRTON – IRISH SETTERS
91.4 x 61cm (36 x 24in)

Rather than have one enormous painting of a whole group of dogs, it is sometimes better to put dogs of the same age together. This restricts the number of relationships you need to deal with and reduces the size of the canvas required. Paint dogs in pairs or threes, grouping them with closer relationships on separate canvases, as is the case here with Casey and Katie (right) and the veterans Sonny and Finnegan (below).

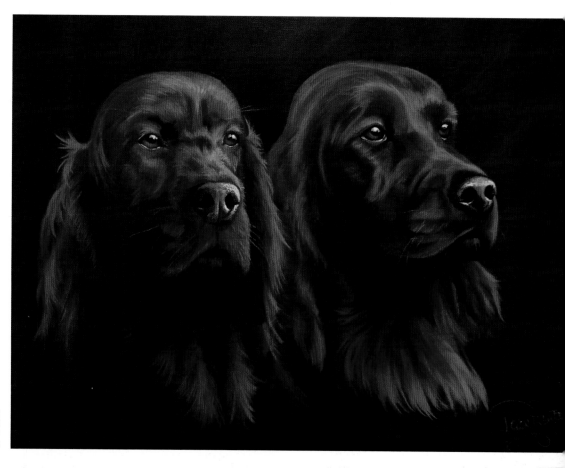

CASEY AND KATIE
– IRISH SETTERS
61 x 45.7cm (24 x 18in)

SONNY AND
FINNEGAN
– IRISH SETTERS
61 x 45.7cm (24 x 18in)

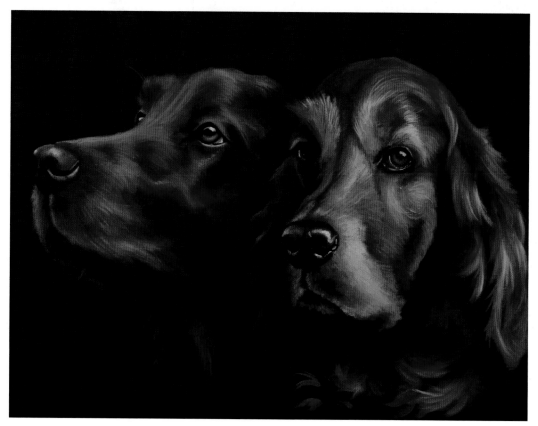

Eleven dogs in one house: eight Yorkies and three Poodles. Not only do you have to take into account relationships, you should also vary the colours so that you generate variety and vitality in the painting. I thought this lot were a team, so I arranged them like a classic, if hairy, football team!

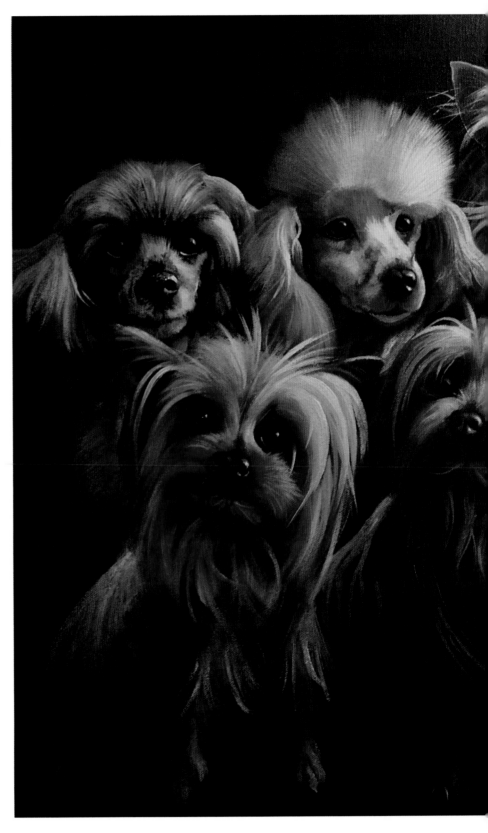

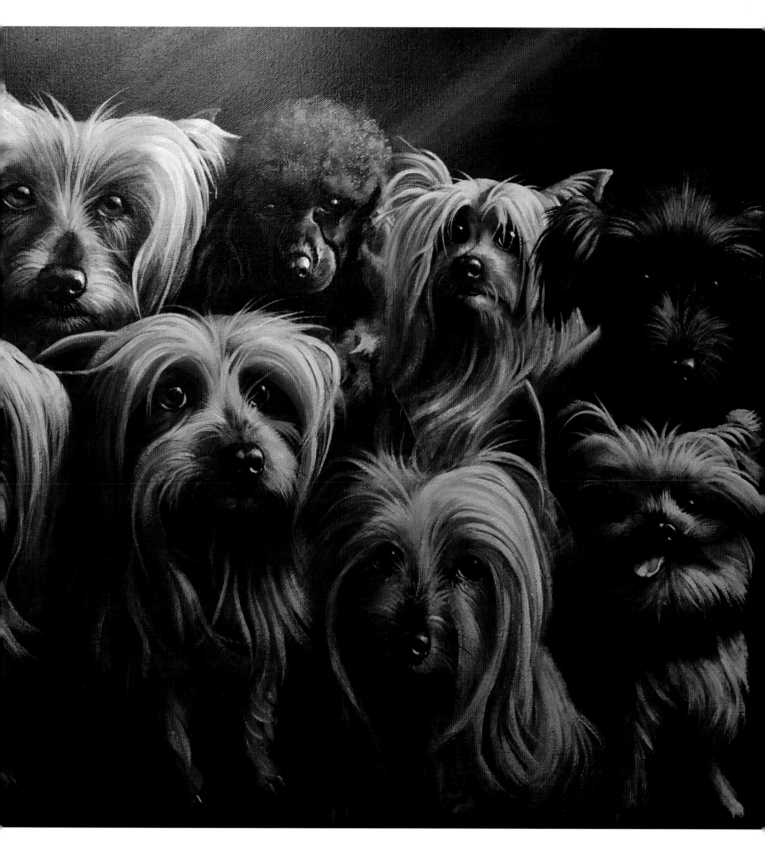

THE GIRLS – YORKSHIRE TERRIERS AND POODLES
99 x 61cm (39 x 24in)

Which dog does your eye rest on? I wonder if it could be the little one front right whose tongue sticks out because she has had a stroke? She is the only one showing a tongue, so it naturally becomes the point of interest in the painting.

POSTHUMOUS PORTRAITS

There will come a time when you are asked to 'resurrect' in a painting a dog or dogs which have passed away. There is no opportunity to meet and greet and you are wholly reliant on the reference photographs your commissioner can supply. In this case there will be a highly sensitive discussion, and you should gauge whether the owner has sufficiently got over the dog's passing and can really cope with a painting on the wall.

I start by asking for a description of the dog's character, the things it liked to do, places it liked to go for a walk and its favourite toy. You will hopefully have a huge amount of photographic reference to choose from, and you can ask for or seek out those photographs which support the description.

At the same time, you are looking for the photographs which show the standard features:

· Markings both sides of the muzzle

· Colour of the fur viewed both indoors and out

· Colour of the eyes

· Signature features.

Next, establish how old the commissioner wants the dog to look in the painting and then make sure you know the key differences between the dog at that age and when it was older.

If you will be painting multiple dogs who are no longer with us, you need to look for photographs which show their comparative heights. If there are none showing all the relevant dogs, look for the relative heights against a common feature, which might be the owner or the house. Failing that, ask for the owner's recollection of the dogs' relative heights.

BRUNO, LEO AND KHYBER – RETRIEVERS
91.4 x 61cm (36 x 24in)

Although there was some crossover in their lives, I relied heavily on the owners for their descriptions of the dogs' characters, so that I could emphasize their different natures. For instance, although they were all fun-loving, Khyber was also described as 'very emotionally intense'.

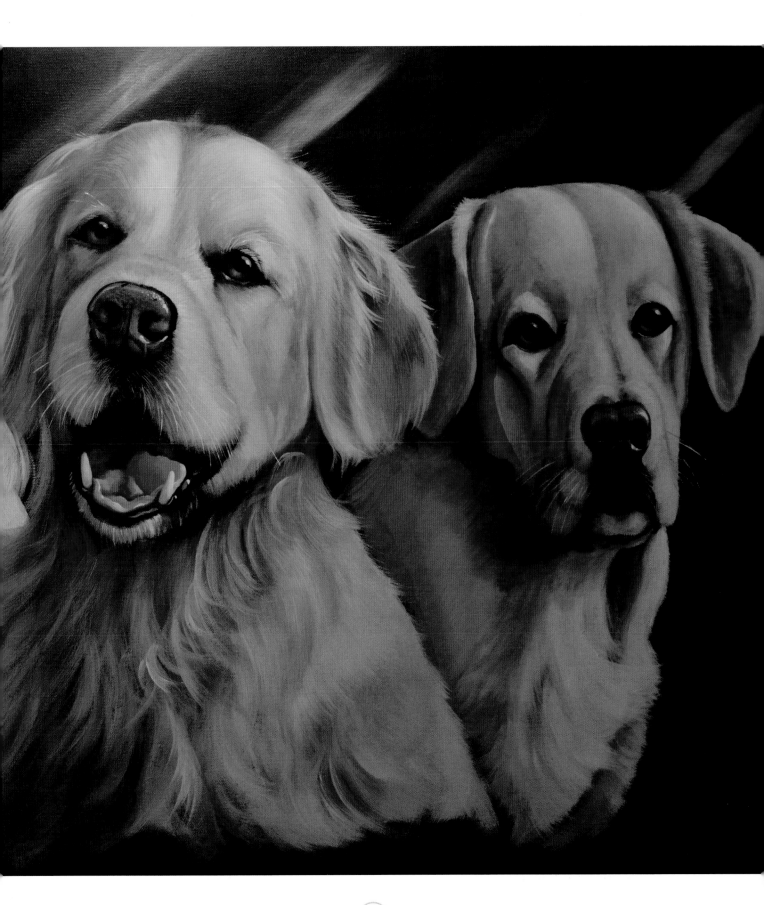

TRUE TALES

Rita met me at Crufts in 2015. She was in tears asking if I could bring her dogs, Fee and Femke, back to life. Both had qualified for Crufts but tragically died before the event, and it had been such a shock for the owner to lose both dogs so very young. Key issues to establish when I took on the commission were the dogs' heights and who was the more confident.

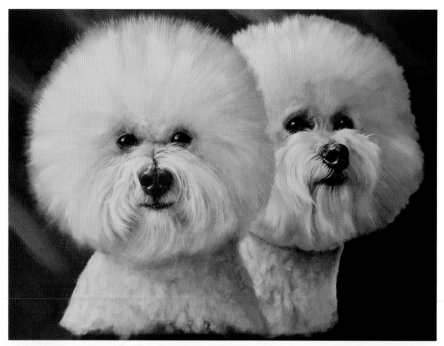

FEE AND FEMKE – BICHON FRISE
61 x 45.7cm (24 x 18in)

MISTY AND PHOEBE – ENGLISH BULLDOGS
61 x 45.7cm (24 x 18in)

Apart from the markings, the fundamental difference between these two was that Misty was a blue-white and Phoebe a red-white.

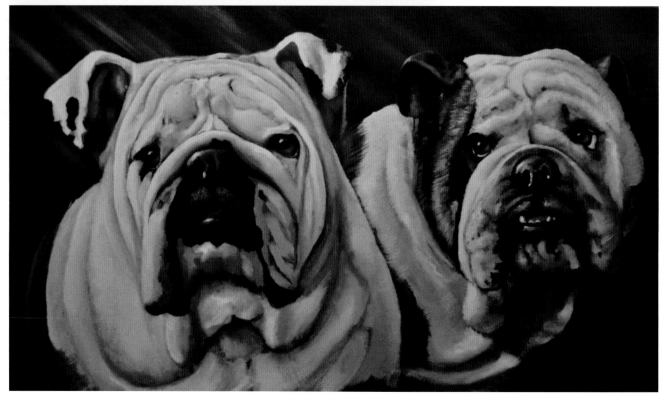

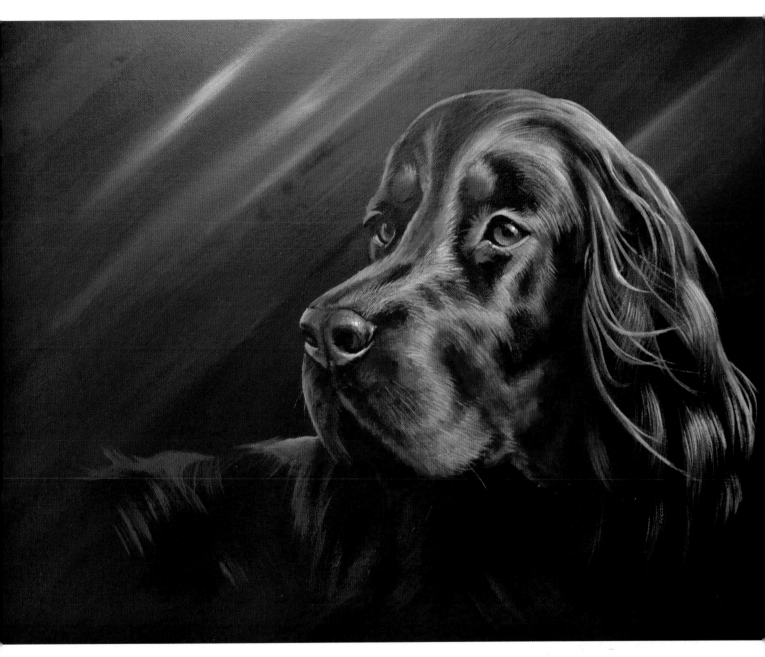

I met Beryl at Crufts in 2012. She wanted to know if I could paint her prize Gordon Setter but take seven years off him, as he was fourteen now and past his prime. I agreed and said that although he was getting on, I would like to meet him. I asked for her contact details, and when it came to her phone number, the area code was the same as mine! Beryl had travelled 200 miles to Birmingham and it turned out she lived just two miles up the road from me, so I walked round and met Barna B. He was apparently a shadow of his former self, with not much colour in his face and very little weight on him, but he had a confident air about him. He passed away before I finished the painting so it was really poignant to have done the commission at that stage.

BARNA B –
GORDON SETTER
61 x 45.7cm (24 x 18in)

MILEE – SHIH TZU
50.8 x 40.6cm (20 x 16in)

I didn't get to meet Milee the Shih Tzu in person, but she was described as a happy little dog who got involved with everything.

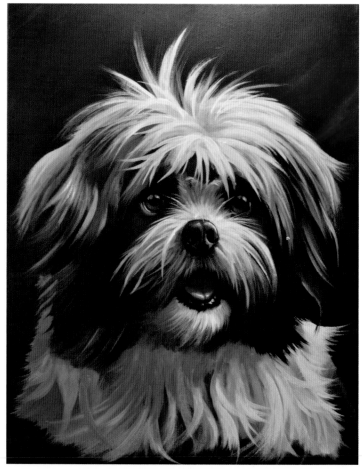

ELLIE AND LOTTIE – COLLIES
81.3 x 50.8cm (32 x 20in)

There were two aims when I took on this painting: first, to surprise the commissioner's wife with an image which not only included their current dog but also the Collie from her childhood which had passed away. Second, the commissioner had unfortunately missed buying his wife an anniversary present, so the pressure was on to do something very special for her birthday!

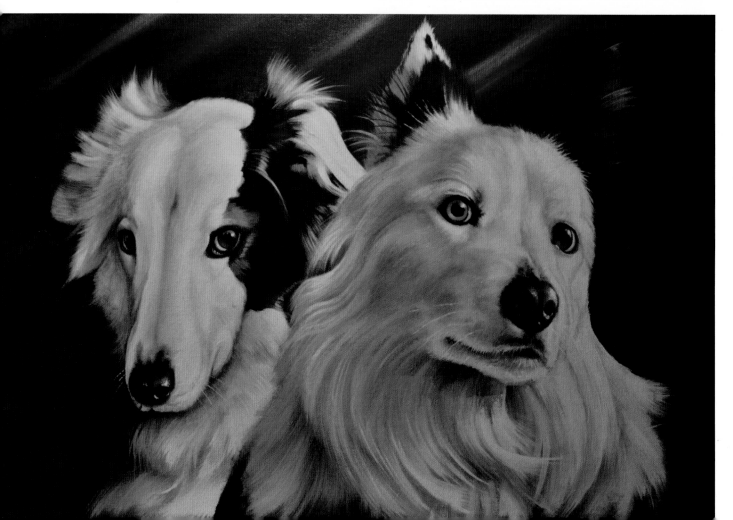

LILY – GOLDEN LABRADOR
61 x 45.7cm (24 x 18in)

The background here depicts the family's favourite walk.

THE Bs – IRISH SETTERS
91.4 x 61cm (36 x 24in)

The customer for this painting wanted 'to capture the beauty of my dogs forever – those departed and those still with me'. The painting defies time as three of the four of the dogs shown have now died. The owner finds comfort in the impression that they are still with her.

Overleaf
EZRI – DOBERMAN
61 x 45.7cm (24 x 18in)

PROJECTS

Willow

Willow was a black & white Springer. She was getting on when I met her and she had been a devoted family member forever, so her owners wanted me to capture her essence in a painting. She was a working dog, particularly attentive to the father of the family. The day I was about to start this painting in the studio, she sadly passed away.

This is how I put together any portrait on a square canvas. I used a block canvas for this commission, but you could use a gummed block of watercolour practice paper or a canvas board. I painted it with a mix of ultramarine and Mars black, before plotting the main points of the drawing on a diagonal grid (see page 37).

YOU WILL NEED

Canvas board or watercolour practice paper, 60 x 60cm (23⁵/₈ x 23⁵/₈in)

White blackboard chalk

Scrap card for whiskers

Acrylic paints: ultramarine, Mars black, cadmium red deep, titanium white, burnt umber

Brushes: no. 8 round, no. 16 rake, no. 12 rake, no. 4 flat, no. 2 rigger, long rigger, no. 0 rigger

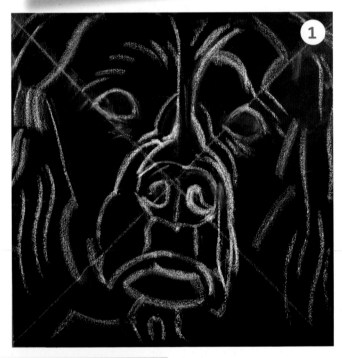

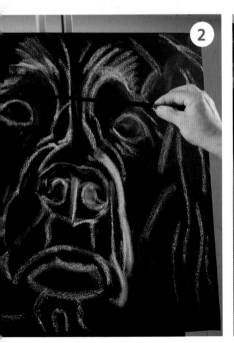

1 Paint the background and draw the outline as shown on page 37.

2 Rub off the lines and make adjustments. Find the angle of the eyes and make sure this aligns with other angles, such as the top of the nose and the nostrils.

3 Paint the darkest parts with ultramarine and Mars black using a no. 8 round, going from bluer to blacker, right to left, as the light is from the right.

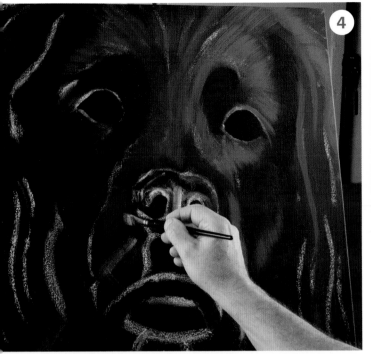

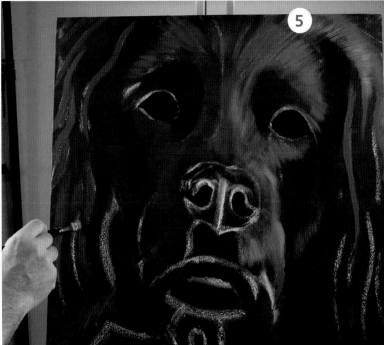

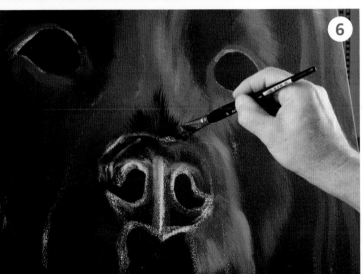

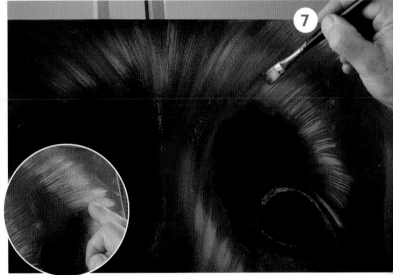

4 Take a no. 16 rake and a mix of 85% ultramarine, 5% cadmium red deep, 5% titanium white and 5% Mars black. Paint directional brushstrokes for hairs radiating round the face. Make the left-hand side of the face darker and redder to suggest shadow.

5 Add titanium white to the mix and develop the highlighted hair on the top right, changing the angle to go with the direction of the coat. Go back to the darker mix and paint flowing locks of hair on the left-hand ear with gentle S-shaped brushstrokes, thicker in the middle and thin at the ends.

6 Paint the same dark blue on the eyelids with the side of the brush, then mix ultramarine and Mars black and paint the dark patch of hair rising from the nose.

7 Change to the no. 12 rake and a much lighter purple mix of titanium white, cadmium red deep and ultramarine. Continue painting the hair on the lit side of the dog. Smudge with your finger to blend in places, creating a soft, natural look to the hair.

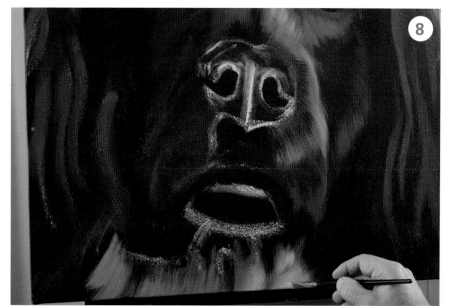

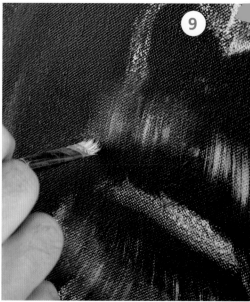

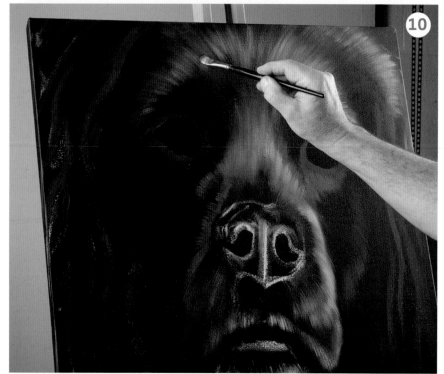

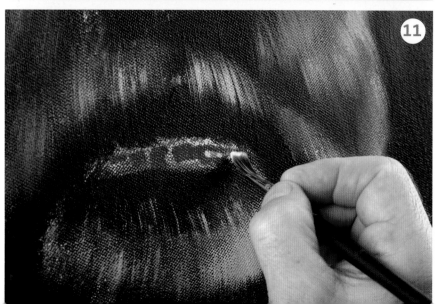

8 Paint the chest hairs and the bottom of the block canvas with a light purple mix of titanium white, ultramarine and cadmium red deep. Add more white on the right-hand side.

9 Brush in the hairs on Willow's chin in the same way. Load the brush and paint from left to right, so that the paint runs out as you go and the right-hand side appears lighter. Paint the hairs above the top lip with a lighter, bluer mix.

10 Continue painting the hairs radiating out from the dog's nose, adding lighter hairs on the right of the muzzle. Add more red and blue to the mix and paint the shadowed side on the left of the muzzle and above the eye.

11 Use a no. 4 flat to paint the dog's lip with the same purple mix with short, downward strokes. While this is wet, paint little strokes of titanium white on top to make the lip look wet.

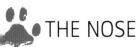

THE NOSE

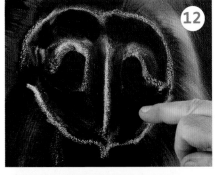

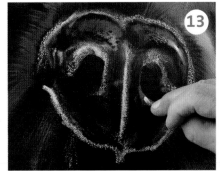

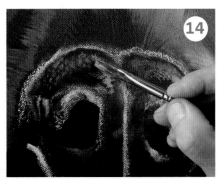

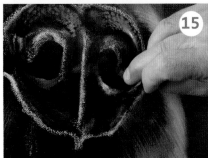

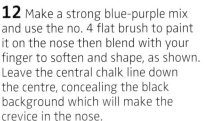

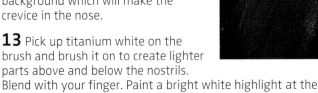

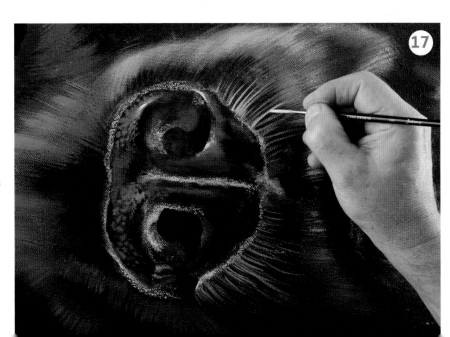

12 Make a strong blue-purple mix and use the no. 4 flat brush to paint it on the nose then blend with your finger to soften and shape, as shown. Leave the central chalk line down the centre, concealing the black background which will make the crevice in the nose.

13 Pick up titanium white on the brush and brush it on to create lighter parts above and below the nostrils. Blend with your finger. Paint a bright white highlight at the bottom right and smudge it to pull it out.

14 Use the corner of the brush and a light purple mix to dab on texture across the top of the nose, leaving negative spaces in between.

15 Imply the receding insides of the nostrils by painting on a dark blue mix, then blending the edges with your finger.

16 Mix a light blue and blend the highlight in with the darker background, then paint a vertical line either side of the central crevice.

17 Use the no. 2 rigger and a very pale blue-white to paint the hairs, below the nose, turning the painting if you need to. Add white hairs on top.

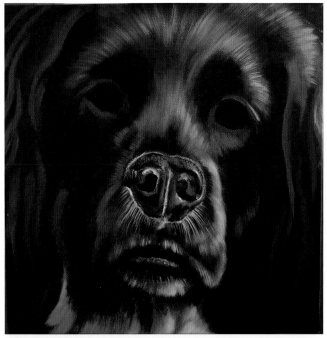

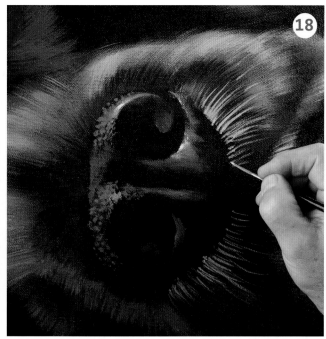

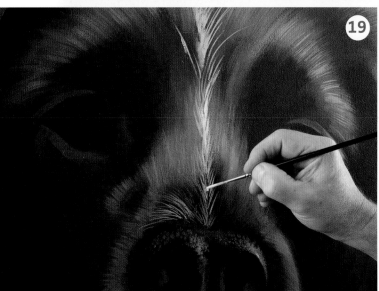

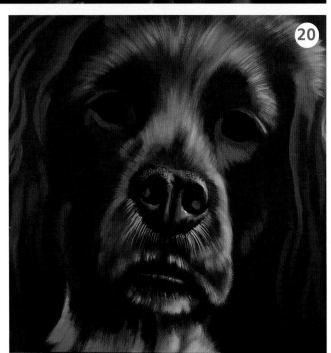

18 Stand back to assess the painting so far (top left). Once it is dry, remove all the remaining chalk. Remember this is a portrait and tiny details can make all the difference in achieving a likeness. Make any further adjustments necessary (top right). I lightened the purple on the left of the nose by making a bluer, lighter mix of titanium white, ultramarine and cadmium red deep and brushing on hairs with a rake. I changed to a no. 2 rigger and extended the white hairs below the nose (with the painting on its side), to slim and reshape the base of the nose. Brighten the textured highlights on top of the nose with the blue-white mix. I slightly raised the top of the nose with a darker blue-white mix.

19 You may need to make a chalk mark to remind you of the height of the white flash up the centre of the muzzle. Use the no. 2 rigger and a very pale blue-white to paint the hairs, turning the painting if you need to. Add white hairs on top.

20 Make any further adjustments. I darkened the purple on the dog's lip.

21 You could use the rake method of painting the long hair as shown on page 47, but because I was using a large canvas, I used a long rigger to paint the long hair of the ears. To create a three-dimensional effect, first paint long, curving strokes with a mix of titanium white, ultramarine and cadmium red deep. Smudge the ends with your fingers and make sure you leave gaps between locks of hair.

22 Use a lighter mix to paint further brushstrokes on top. Lighten further where the hair curves out towards the light.

23 Continue, painting the ear on the left with slightly darker paint, again leaving dark gaps between locks.

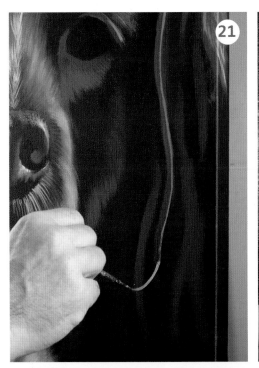

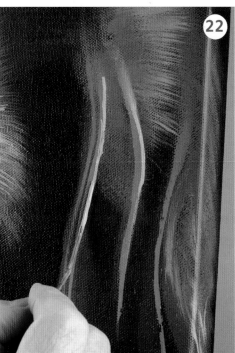

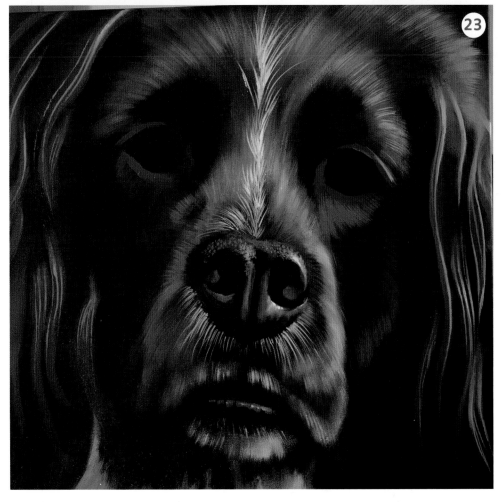

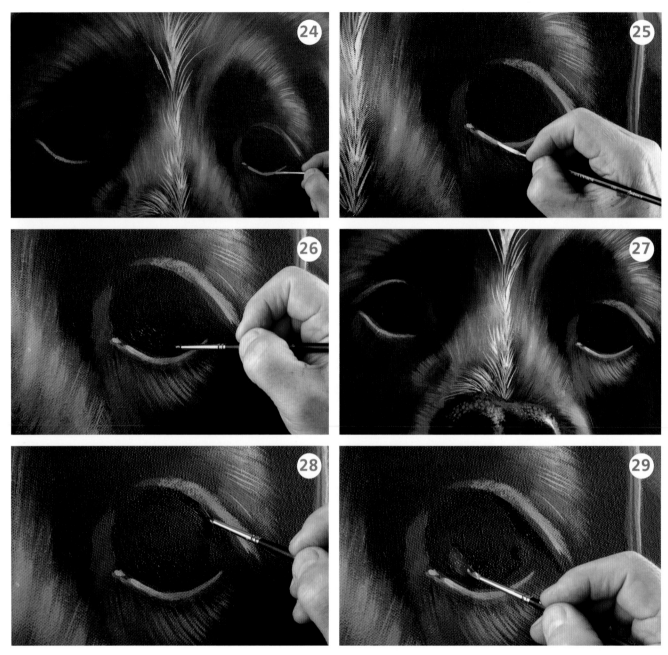

24 Take the no. 0 rigger and paint the lower eyelids in light blue. Leave a tiny rim of the darker blue between the eyelid and the black background of the eye. Wet the brush and soften the edge of the eyelid.

25 Add a lighter touch in the inner corner of the right-hand eye. Allow to dry.

26 Lighten the hairs below the right eye with the same brush. Now paint the irises of both eyes with burnt umber, making sure the shapes match. Paint negatively around the shape of the pupils.

27 You can adjust the look of the eyes and make them match by painting Mars black and ultramarine to reshape the pupils. I made sure Willow was looking down at this stage, as the painting was going to look down at the viewer from its place on the wall.

28 Redefine the tops of the eyes by using the same blue-black to shape beneath the upper eyelids.

29 Lighten the left-hand side of the irises with a mix of titanium white and burnt umber. Dogs' irises pick up light on the side opposite to that from which it is coming.

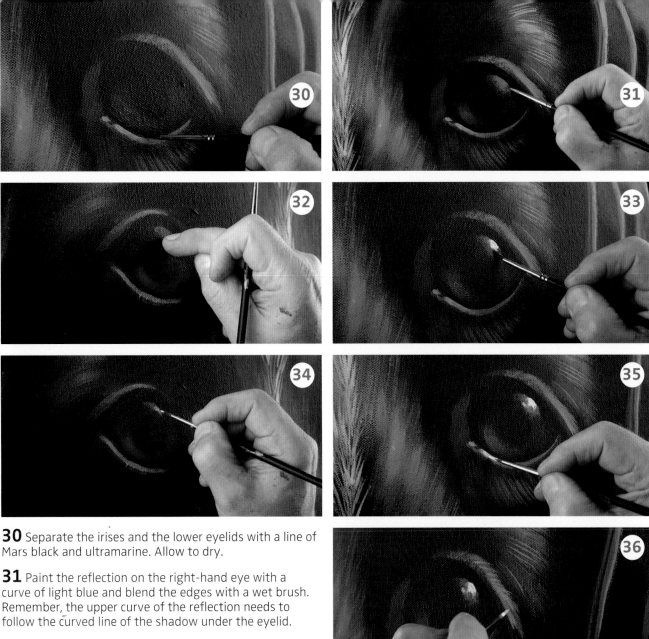

30 Separate the irises and the lower eyelids with a line of Mars black and ultramarine. Allow to dry.

31 Paint the reflection on the right-hand eye with a curve of light blue and blend the edges with a wet brush. Remember, the upper curve of the reflection needs to follow the curved line of the shadow under the eyelid.

32 Add cadmium red deep to the mix and do the same in the left-hand eye. Blend with your finger.

33 Pick up titanium white on the tip of the rigger and paint a dot of highlight on the right-hand eye. Wet the brush and diffuse the highlight.

34 Paint an even tinier highlight in the left-hand eye and diffuse it in the same way.

35 Paint a pale blue highlight on the lower lid of each eye.

36 Mix a very light blue and paint eyelashes on the right-hand eye with tiny flicks of the brush.

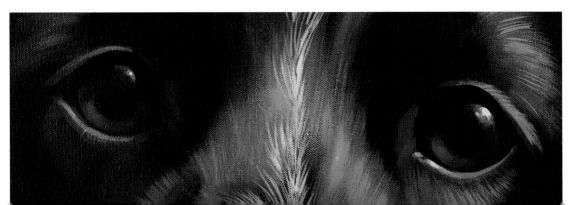

The finished eyes.

WHISKERS AND FINAL ADJUSTMENTS

37 Use a piece of card (I used a cheque book cover) to paint the whiskers. Paint the edge of the card with titanium white mixed with touches of ultramarine and cadmium red deep. Use this at varying angles to 'print' the paint onto the canvas to create the whiskers. Adjust the curve of the card as you go. I painted seven on the left and five on the right, then used a smaller piece of card to paint smaller ones in front. The whiskers on the right-hand side should be lighter.

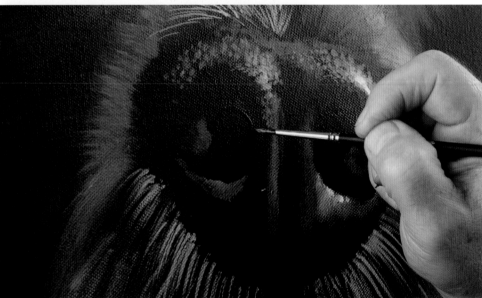

38 At this point I stood back to assess the painting and made a few adjustments. I mixed a dark blue from ultramarine and a touch of Mars black and closed the nostrils a little.

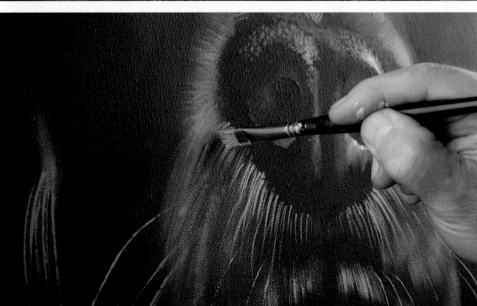

39 I lightened the hairs round the edge of the nose to increase the contrast and hence bring this part of the painting forwards. It should look like the part nearest the viewer.

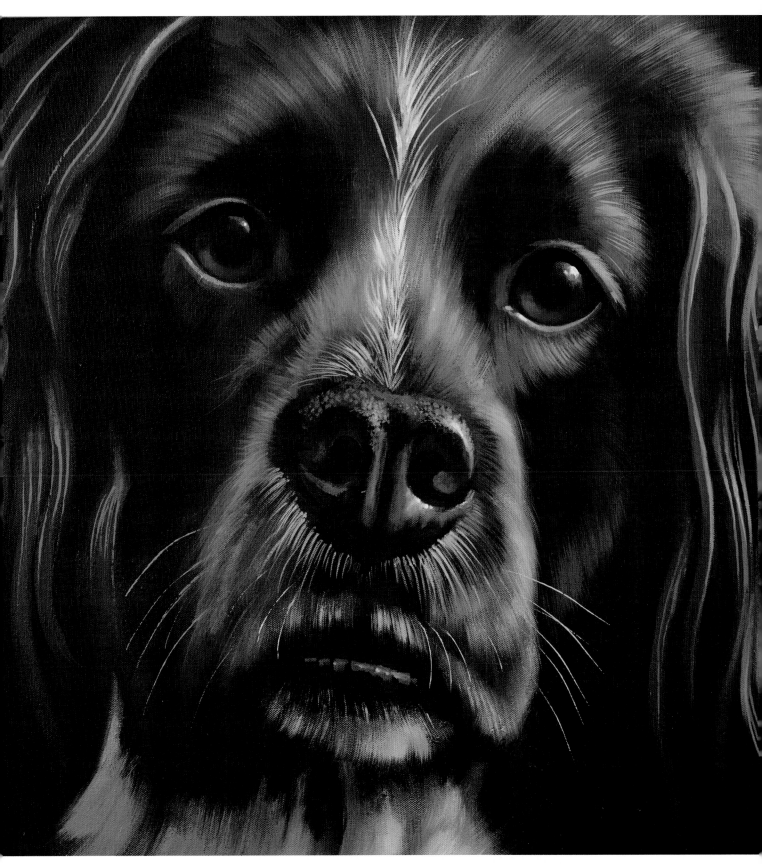

The finished painting. Although it may look a little too blue, you will be amazed how this darkens when the painting is put in a room with the warm, yellow light produced by most light bulbs.

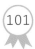

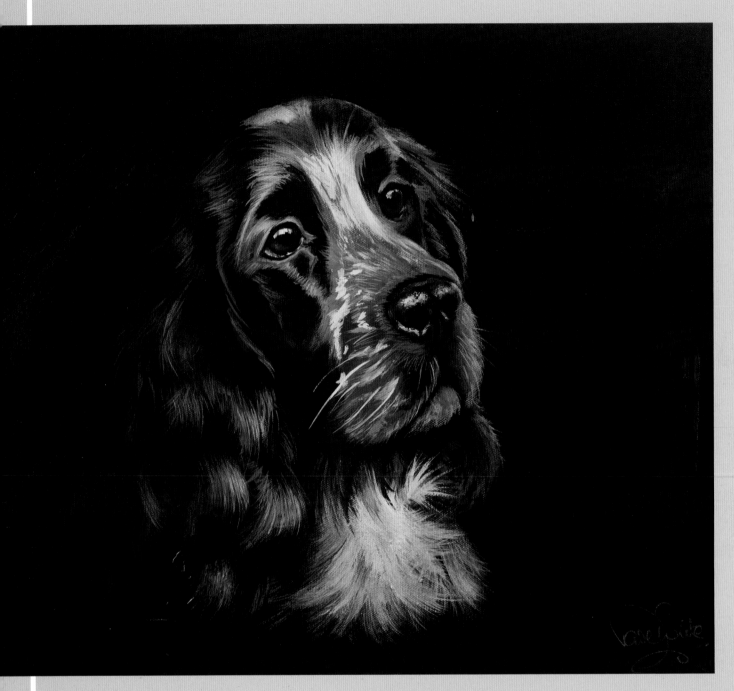

SACHA – COCKER SPANIEL
50.8 x 40.6cm (20 x 16in)

Sacha is a blue roan Cocker Spaniel, but this is one of my 'standard' paintings, made up from five earlier commissions of different blue roans.

Opposite
RODNEY – COCKERPOO
61 x 45.7cm (24 x 18in)

This portrait was commissioned by friends of Mark and Gill for their 25th wedding anniversary. The couple use it as their screensaver, and the wife says goodnight to Rodney every night when she turns off the computer! All the photographs provided of Rodney were very flat, with very little shade, so I emphasized the shade to make him look three-dimensional.

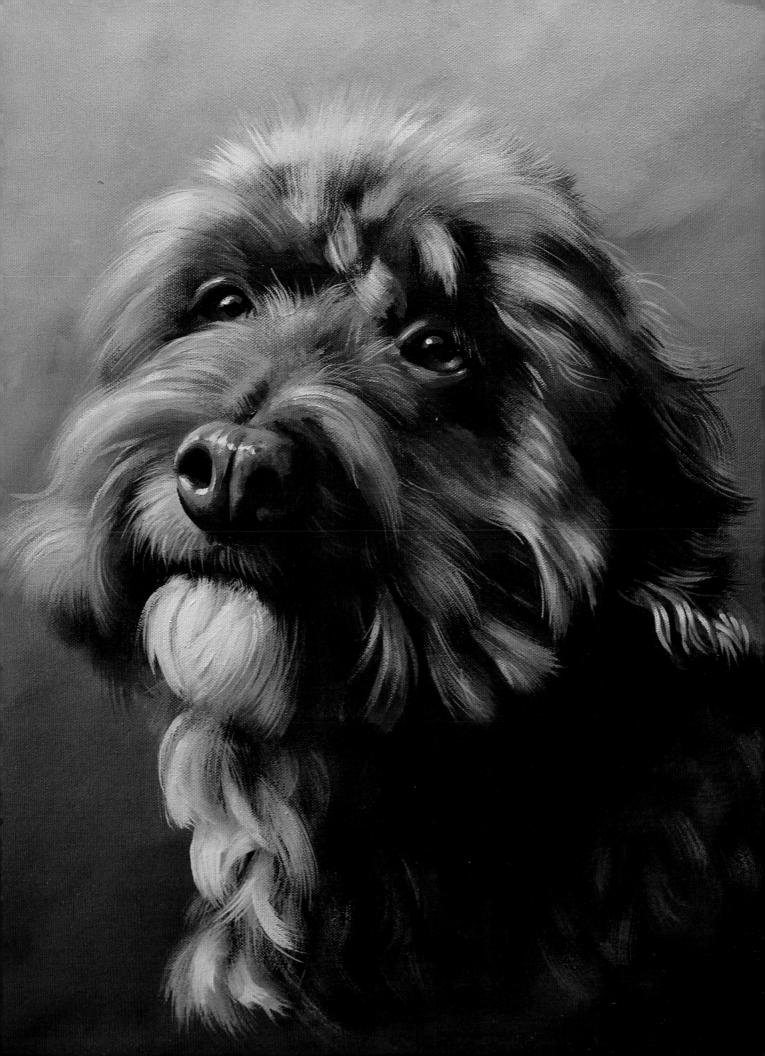

Alfie

The leafy background for this painting was also used for the profile of Alfie shown on pages 35 and 116. The objective of this project is to show how to shadow a white dog in extreme lighting. I have also chosen to open Alfie's mouth and expose his tongue, showing that you can vary what you see in your initial photographs, using further reference photographs to help.

YOU WILL NEED

Canvas board or watercolour practice paper, 61 x 45.7cm (24 x 18in)

White blackboard chalk

Scrap card for whiskers

Acrylic paints: Hooker's green, ultramarine, Mars black, titanium white, cadmium red deep

Brushes: 2.5cm (1in) round, 2.5cm (1in) flat, no. 6 round, no. 0 rigger, 13mm (½in) round, no. 8 rake

1 First establish the direction of the light, here coming from left to right. Mix Hooker's green and ultramarine with just enough water so that the paint holds its texture but becomes transparent. Practise first on scrap paper or in the palette. Dab onto the canvas using a 2.5cm (1in) round brush. Turn the brush to vary the effect, creating the look of natural foliage. Make sure the paint is lighter to the left of the painting.

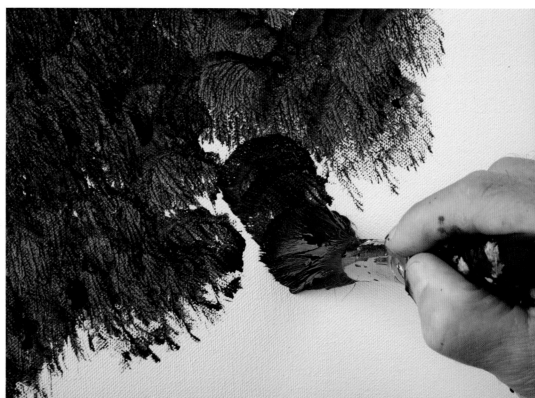

2 Cover the canvas, including the sides, making sure the background is lighter on the left. Allow to dry. Mix Hooker's green with ultramarine and water to make a transparent mix and use a 2.5cm (1in) flat brush to glaze this over the right-hand side of the painting to darken it further. Allow to dry.

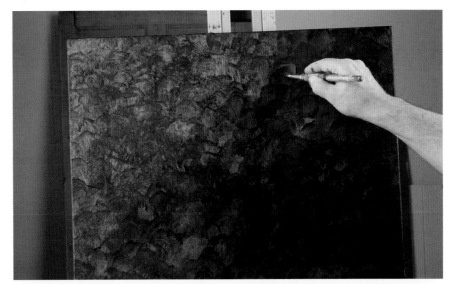

3 Divide the canvas into three, both horizontally and vertically, with white chalk lines, and plot the main points of the drawing on this grid: the right-hand eye is at the corner of the top right-hand third (see inset). Plot the other points in relation to this and begin to fill in the drawing, rubbing out with a rag as necessary. I added the tongue from a second reference photograph of Alfie.

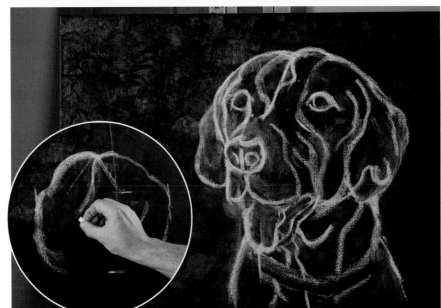

4 Take a no. 6 round brush and mix Mars black with a little ultramarine. Paint the darkest parts, starting with the eyes, painting up to the inner edges of the chalk lines. Don't worry about accuracy, as these darkest spaces will be encased by later stages and can be adjusted. Blend with your finger where they graduate into lighter areas, for instance at the tops of the ears. Continue painting crevices with a slightly bluer, lighter mix.

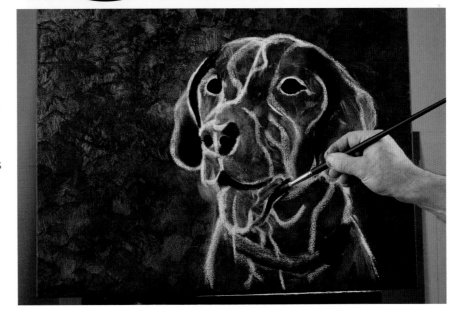

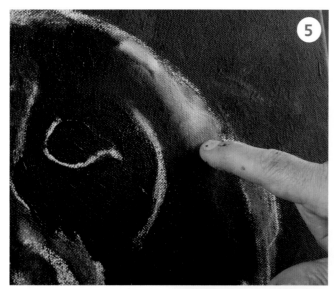

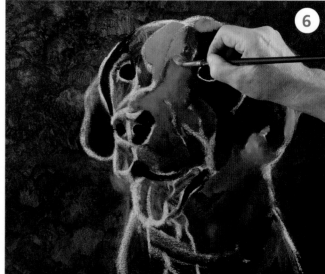

5 Paint titanium white onto the edge of the ear while the blue-black paint is wet and blend it in. Continue in this way, creating the markings on the right-hand ear. Allow to dry.

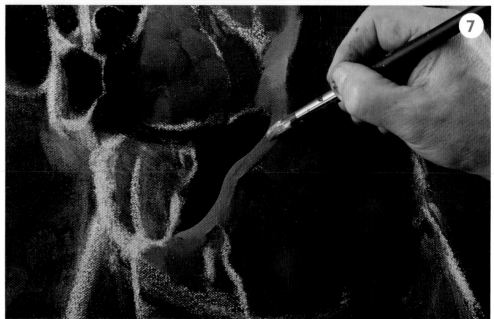

6 Make a purple mix from ultramarine, cadmium red deep and titanium white for the warm shadows on the white parts of the dog. With the no. 6 round, paint this quite darkly under the chin, then make it lighter for the shadows on top of the head. Blend with a scrubbing motion of the brush to create contours.

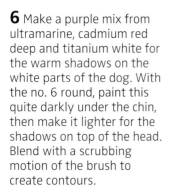

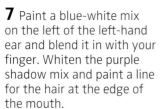

7 Paint a blue-white mix on the left of the left-hand ear and blend it in with your finger. Whiten the purple shadow mix and paint a line for the hair at the edge of the mouth.

8 Paint titanium white on the lit left-hand edge of the neck and blend it in with your finger. Continue painting white on the left of the muzzle and for the brightest highlights on the head, and blend. Allow to dry.

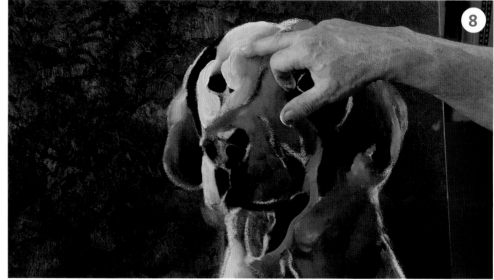

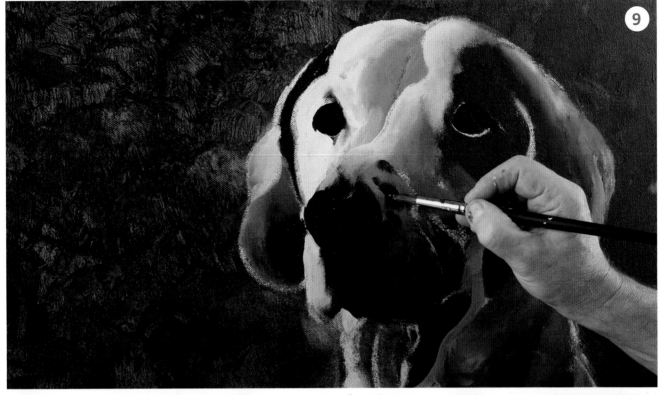

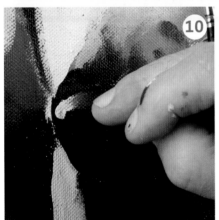

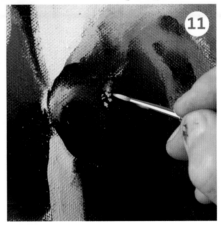

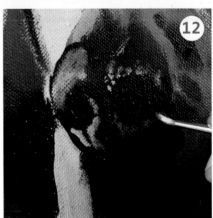

9 Mix a dark blue-black for the base colour of the nose and then paint the dark markings on the muzzle with the same mix.

10 Use the no. 0 rigger to paint a curved white highlight on the nose and blend with your finger.

11 Paint tiny dabs of titanium white on the right of the nose, leaving dark negative spaces for the texture.

12 Paint the underside of the left-hand nostril with white marks. On the right, paint on texture in light blue mixed from ultramarine, titanium white and a little Mars black.

13 Dab on tiny white highlights at the top left of the nose.

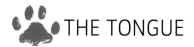

14 Define the top of the nose by painting the line of white hair that leads down to it with the no. 6 round. Highlight the cheek on the left of the nose and blend with your finger. Paint the dark background of the tongue with cadmium red deep and Mars black.

15 Lighten the mix with titanium white and use this to paint each side of the tongue, leaving the crevice in the middle dark by painting negatively around it.

16 Highlight the left-hand side of each side of the tongue with titanium white and blend with your finger.

17 Paint the collar in a similar colour to the tongue. This gives the painting a sense of harmony: without it, the tongue would be the only pink element.

18 Now work on the shadowed areas of the dog. Use a 13mm (½in) round brush to paint on a dark purple mix of ultramarine and cadmium red deep under the right-hand ear. Blend with your thumb.

19 Paint pale shadows on the right-hand cheek and blend. Mix ultramarine and titanium white to paint a blue highlight on the black line between the left-hand ear and the face. Blend to form a shadowed area. Define the spots on the right of the nose by painting negatively round them with the shadow mix.

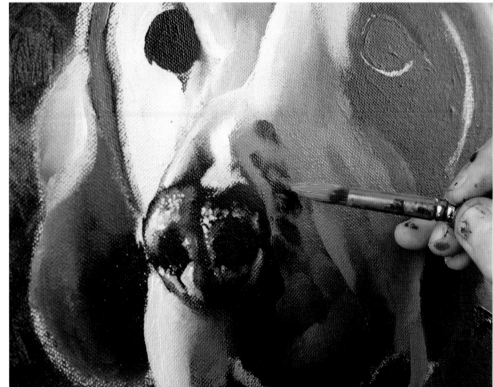

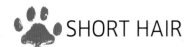

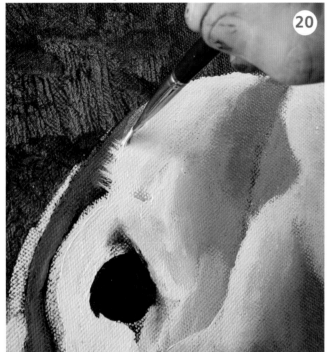

20 Begin to paint the texture of the dog's hair with a no. 8 rake and pure titanium white. Edge the highlighted area to the left of the head with short brushstrokes. The rake's long, separate hairs create the effect of dog hair.

21 Change to the shadow mix and edge the shadowed area in the head crevice in the same way. Using white, suggest hair on the white nose flash.

22 Add soft fuzz on the left-hand cheek with the rake and titanium white. At this point in the painting, I redefined the left-hand eye and added an eyelid with a no. 0 rigger and Mars black with ultramarine. Allow the painting to dry.

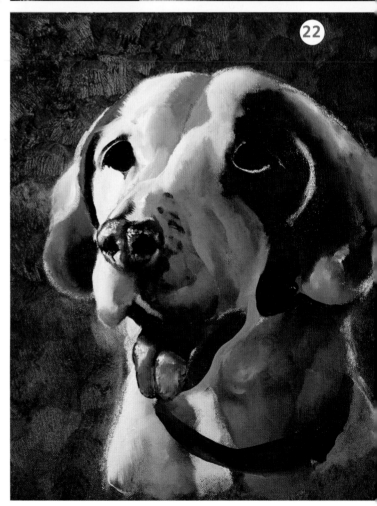

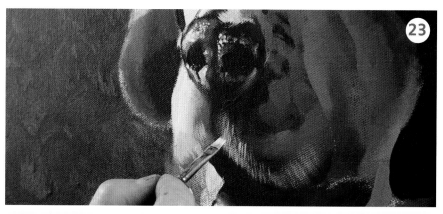
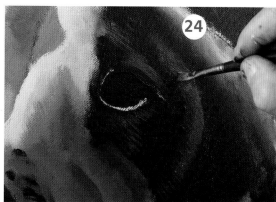
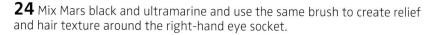
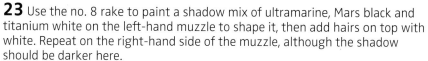
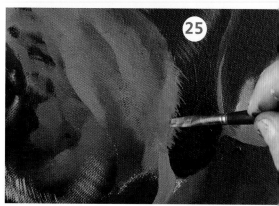

23 Use the no. 8 rake to paint a shadow mix of ultramarine, Mars black and titanium white on the left-hand muzzle to shape it, then add hairs on top with white. Repeat on the right-hand side of the muzzle, although the shadow should be darker here.

24 Mix Mars black and ultramarine and use the same brush to create relief and hair texture around the right-hand eye socket.

25 Paint a mix of titanium white and ultramarine around the white right-hand cheek area, then create white fur on the edge of the right-hand ear.

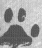

WHISKERS

26 When the painting is dry, rub off the chalk with a rag. Paint the straight edge of a piece of card with titanium white. Use this to print whiskers onto the left-hand muzzle. Continue, bending the card to create different angles for a natural look.

The finished whiskers.

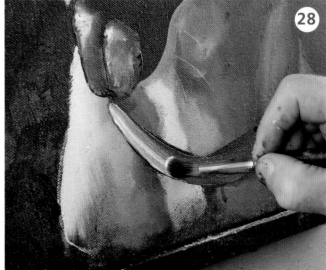

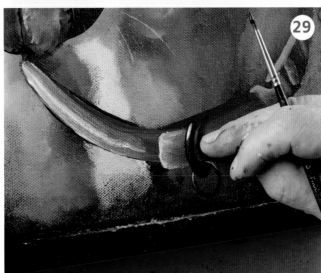

27 Mix the shadow colour: titanium white, ultramarine and cadmium red deep, and use the card again to print whiskers onto the right-hand side of the muzzle. Take a similar mix and use the no. 6 round brush to dab on markings around the roots of the whiskers, then blend these in with your finger.

28 Paint cadmium red deep on the collar, then, while this is wet, paint titanium white on top and blend it in. Leave a dark line at the top. The collar should be lighter on the left-hand side.

29 Paint the details of the clip on the right with a no. 0 rigger and a purple and white mix, then add the buckle with more titanium white. Mix Mars black and cadmium red deep to paint the rings in front and highlight them with white. Mix purple with water to make a glaze and paint the shadow of the ring. Blend to soften.

The painting so far.

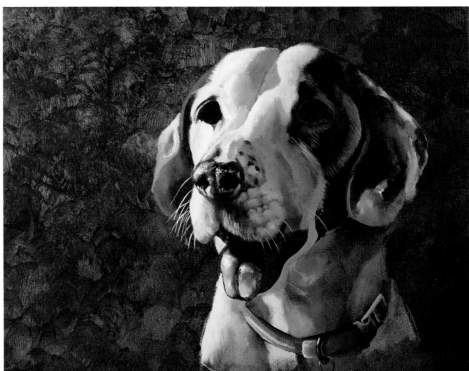

• *The eyes*
Next paint the eyes as shown on pages 66–67.

FINAL ADJUSTMENTS

As with any portrait, tiny variations can make the difference between creating a realistic image, not to mention a good likeness! At this stage, take a break from the painting, then stand back to look at it and assess what changes need to be made. Since Alfie is my dog, any details that were not a good likeness were more likely to jump out at me.

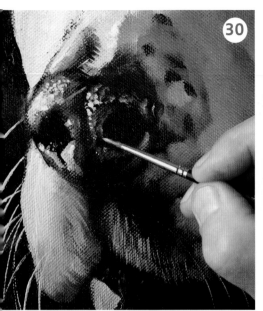

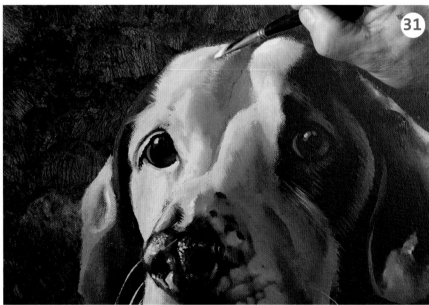

30 I thought the shape of the right-hand nostril needed altering. I redefined it with a rigger brush and a mix of Mars black, ultramarine and titanium white, going round the dark space to correct its shape with negative painting.

31 Alfie's head looked too bumpy, so I lightened the shadow colour (titanium white, ultramarine and cadmium red deep) in the crevice and blended it in to the white hair with a no. 8 rake.

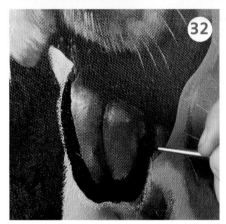

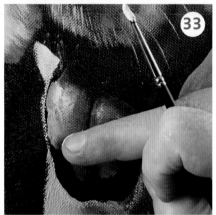

32 Alfie did not quite look his enthusiastic self, and I realized that his tongue was not big enough, and needed to hang our further. I drew on a chalk line to extend the tongue, then painted on the dark red background of cadmium red deep and Mars black using a rigger.

33 I added more titanium white to the mix and painted this over the dark background, leaving a tiny dark edge. I then blended the lighter colour in with my finger. I added more varied pink over the whole tongue.

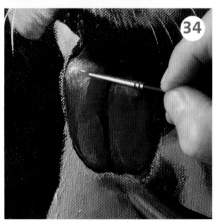

34 I glazed a dark shadow of the tongue over the dog's neck with a mix of ultramarine and cadmium red deep. Finally, I added white highlights on the tongue where it catches the light, to make it look convincingly wet.

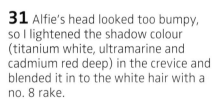

*The finished painting.
I changed the shape
of the inner side of the
left eye socket to show
slightly more of the
left eye, developed the
pattern on the right ear
and added the eyebrow
whiskers.*

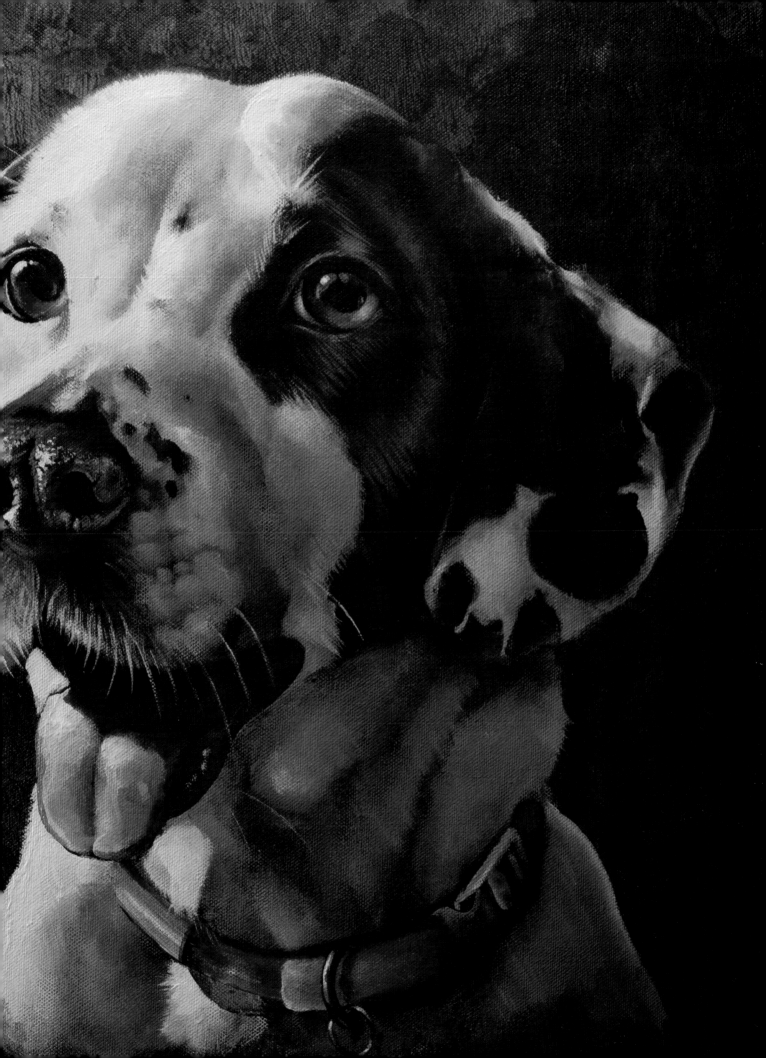

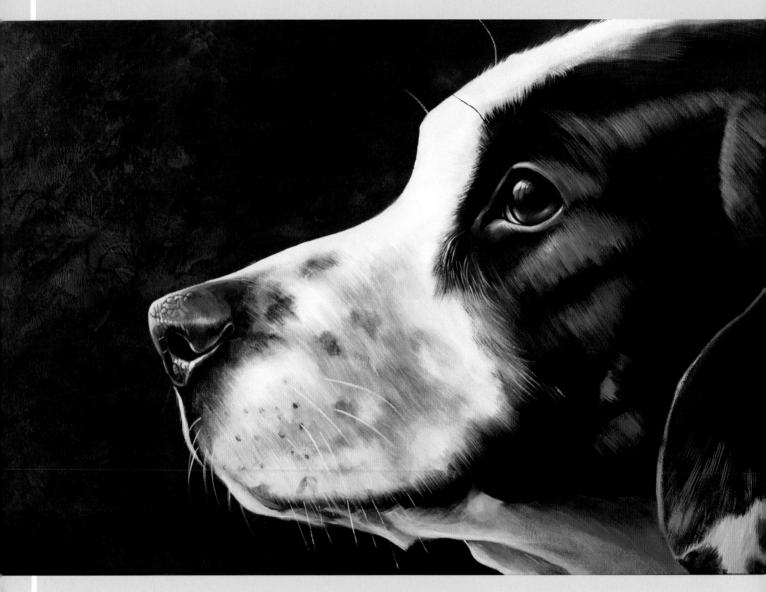

ALFIE – WORKING COCKER SPANIEL/PARSON JACK RUSSELL CROSS
91.4 x 61cm (36 x 24in)

This is our dog, Alfie. My wife loves him to bits and said she'd prefer a painting of him looking out of our window. But if you look really closely, he is still giving us a sidelong glance!

CADBURY – CHOCOLATE LABRADOR
50.8 x 40.6cm (20 x 16in)

Labradors seem to love getting wet, and when they go swimming Chocolate Labs' coats tend to become highly reflective. This means you get not only heavy shadows but also bright, colourful reflections, so here I painted blues and purples on top of the chocolate coat.

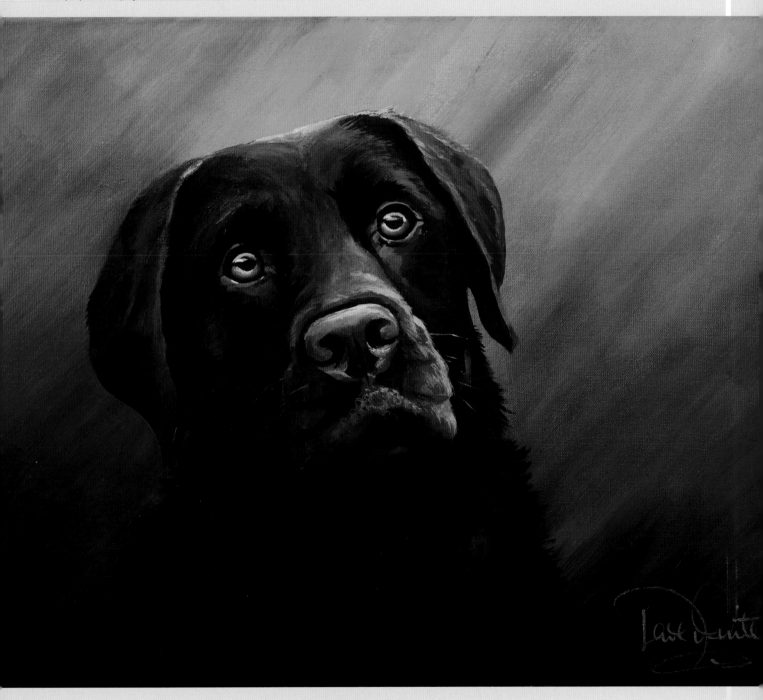

Demelza and Kenzie

Here I paint two dogs, but you can apply these methods to create compositions of multiple dogs. Demelza (left) and Kenzie are Irish 'Red' Setters from a long line of champions. Start with a graduated background (see page 27). The photographs were lit from different directions, but I have standardized the two. The emphasis is on the tonal underpainting which is then glazed over to get the top coat colour.

YOU WILL NEED

Canvas board 91.4 x 61cm (36 x 24in)

White blackboard chalk

Scrap paper for whiskers

Rag for blending

Acrylic paints: Mars black, cadmium red deep, metallic copper, rich gold and pale gold, burnt umber, ultramarine, titanium white, Winsor & Newton burnt sienna

Brushes: no. 6 round, no. 4 flat, 2.5cm (1in) flat, no. 12 rake, no. 2 rigger, no. 4 rigger, no. 8 rake, no. 0 rigger

DRAWING

1 After completing and drying the background (see page 27), divide the canvas into three, both horizontally and vertically. I do this by eye. Make chalk marks to show the divisions. The intersections make the perfect place for the focal point of the painting. I plotted Kenzie's eye (the right-hand dog) on the top-right intersection, and marked this with a chalk cross. Working from the reference photograph and scaling up, plot the top of Kenzie's head, then do this for Demelza on her left. Also plot the outer edge of Demelza's muzzle and the base of each dog (a point on the dog's chest, since this is a head and shoulders portrait).

2 Once the major points are plotted, begin to draw both dogs from the reference photographs. I have raised Demelza's outline and pointed it more to the left so her face is at a different angle from Kenzie's.

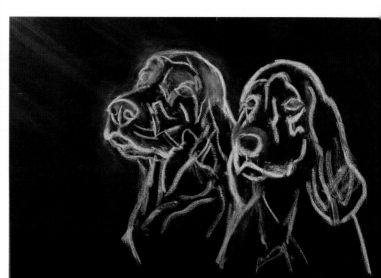

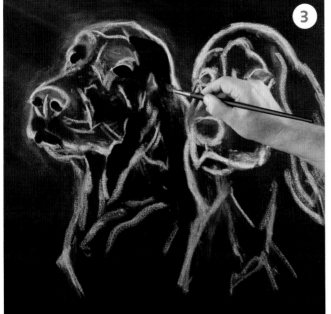

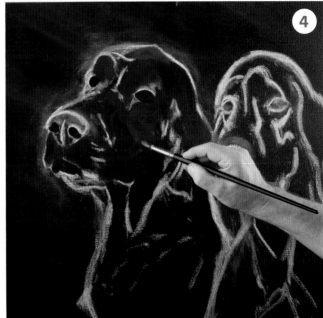

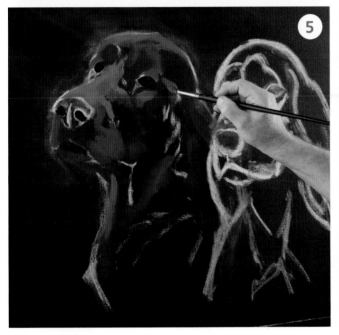

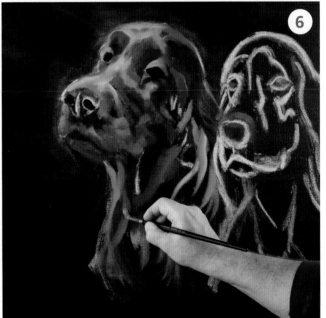

3 Mix burnt umber and ultramarine and use the no. 6 round to paint the darkest areas of Demelza – the eyes, orifices and deep shadows.

4 Make a slightly lighter mix, with less blue, and paint the next darkest parts of the dog, blending the new colour in to the darkest mix as you go.

5 Start adding titanium white to the mix and paint the next lightest patches, blending while the underlying colour is wet.

6 Lighten the mix again and paint the highlights, remembering that the light is coming from the top left, so should catch the dog's head, muzzle and chest, and part of the ear. Paint long, curving strokes for the long locks of chest hair.

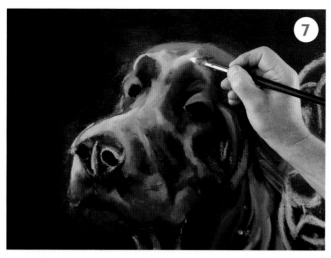

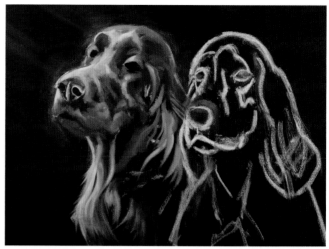

7 Mix in still more titanium white for the lightest highlights and blend in with the wet brush. Allow to dry.

Demelza with the underpainting finished.

 GLAZING

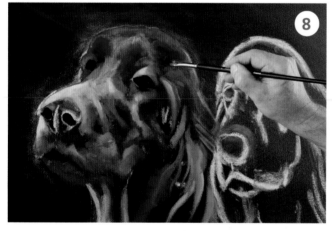

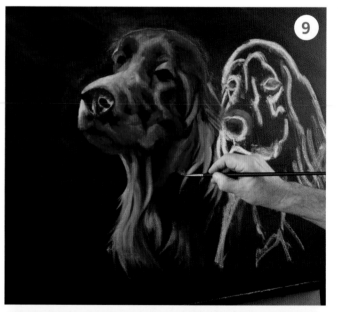

8 Make a glaze from Winsor & Newton burnt sienna mixed with water to produce a waxy, transparent finish. If there is too much paint the mix will be too dark, but with too much water it will run. Paint this over the dried underpainting with a no. 4 flat brush.

9 Glaze over the whole dog, blending in the tonal changes in the underpainting. Take off any hard lines with a rag as you go. Change to a 2.5cm (1in) flat brush for speedier coverage. Allow to dry.

10 Mix the Winsor & Newton burnt sienna with burnt umber for a darker glaze, and paint the shaded areas of the dog. This helps to subdue the orange of the previous glaze and looks more natural. Accentuate the shadows, for instance under the chin, thinking about where the light is coming from.

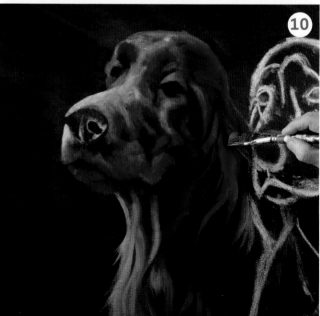

- *The nose*

To paint Demelza's nose, follow the steps on page 55.

PAINTING HAIR WITH RAKES

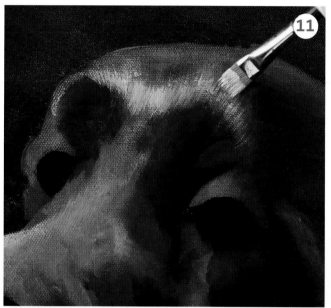

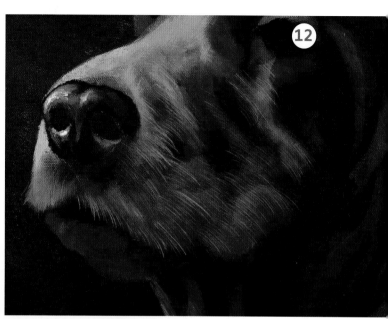

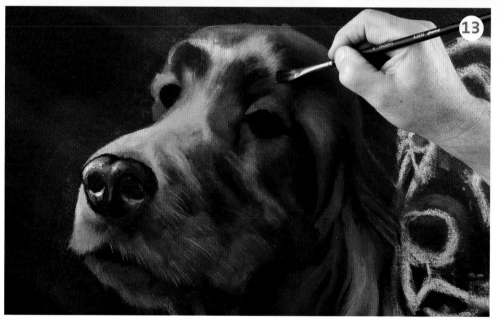

11 Once the nose is complete (see page 55), perfect the shape of the eyes with the same black as for the nose. Change to the no. 12 rake and brush on hairs on the brow with titanium white and a bit of burnt umber.

12 Continue brushing hairs around the muzzle and cheek. Allow to dry.

13 Having painted the effect of the dog's hair, you need to re-establish the glaze. Take the no. 4 flat and brush the Winsor & Newton burnt sienna and water mix over the whole dog.

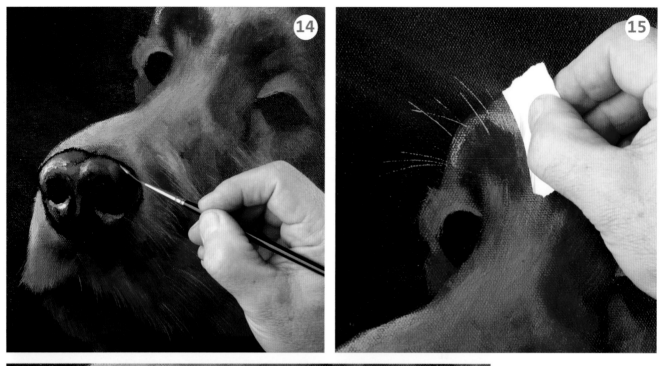

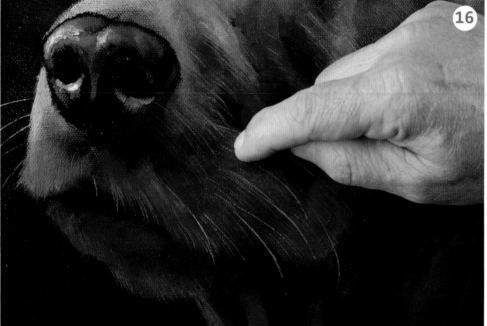

14 Paint the edges of the eyelids with the no. 2 rigger and a mix of ultramarine, cadmium red deep and burnt umber. Paint a reflection of this colour onto the top of the nose to balance the colours.

15 Use the edge of short piece of card to print eyelashes with a mix of titanium white and burnt umber.

16 Use a longer piece of card to print on the whiskers in the same way, then blend in the ends where they grow out of the muzzle, using your finger.

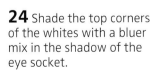

THE EYES

17 Paint the irises with burnt umber, shaping the pupil using negative painting. Blend with water on the brush.

18 Mix titanium white with ultramarine and paint curves for the sky reflections, following the shape of the eye socket.

19 Blend to soften with your finger or a rag.

20 Line the lower edges of the eyelids with ultramarine, titanium white and cadmium red deep, and highlight this area with white while it is wet.

21 Paint white highlights with a wet titanium white mix, making it smaller in the right-hand eye, which is further from the light source.

22 Use the no. 12 rake to paint white hairs between the eyes. Change back to the no. 2 rigger. Lighten the bottom right of the iris with burnt sienna and titanium white, reshaping the dark pupil so that the eyes work together.

23 Paint the whites of the eyes on the left with titanium white and ultramarine. You are aiming for the shape of a windsock. Lighten this with white in the right eye.

24 Shade the top corners of the whites with a bluer mix in the shadow of the eye socket.

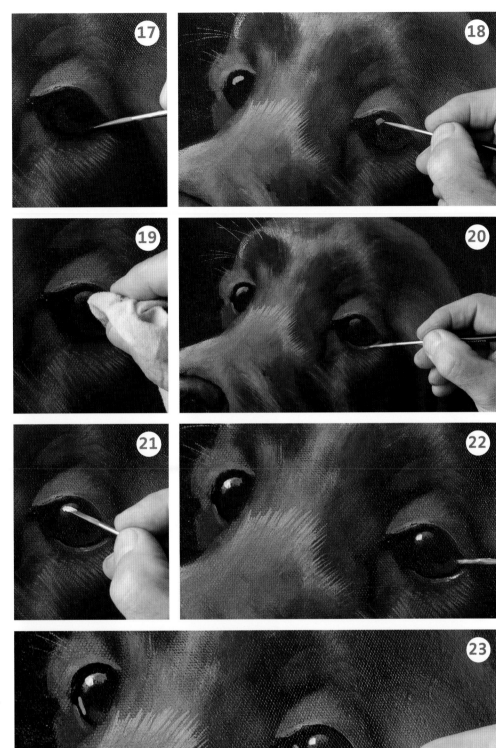

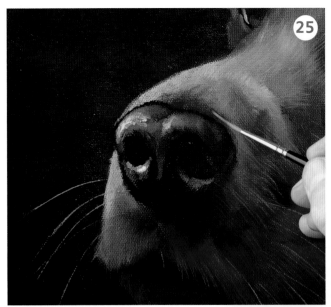

25 When the white hairs on the nose have dried, use a no. 12 rake and Winsor & Newton burnt sienna to glaze over them. Change back to the rigger and paint the small recess above the nose with the same glaze.

26 Make the dog's long hairs look more three-dimensional by painting on highlights in titanium white and burnt umber. Blend these in, then add still lighter ones on top, working in layers.

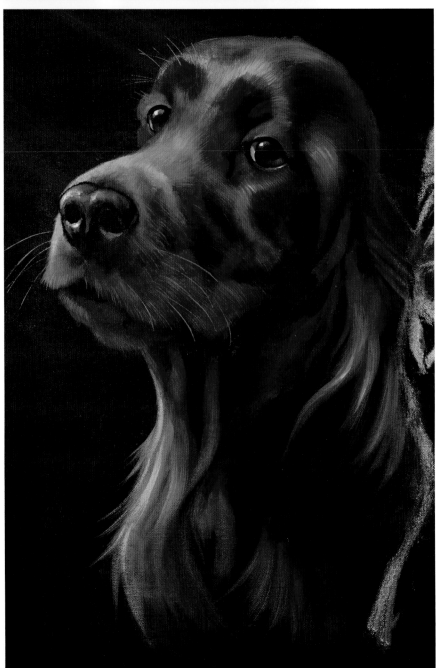

Demelza finished.

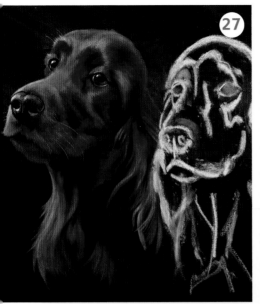

27 Take a step back and identify any issues with Demelza before continuing. I blended together the shades on top of the head to soften the dent there, reshaped the half-moon in the right-hand eye and extended the long locks of the ear. I then removed the chalk and re-glazed with burnt sienna. Demelza must recede into the background, so the tonal contrast in Kenzie must be stronger to bring her forward.

28 Paint the darkest parts of Kenzie with Mars black and ultramarine, using a no. 6 round. Then, add cadmium red deep to warm the shadow and paint the next darkest parts.

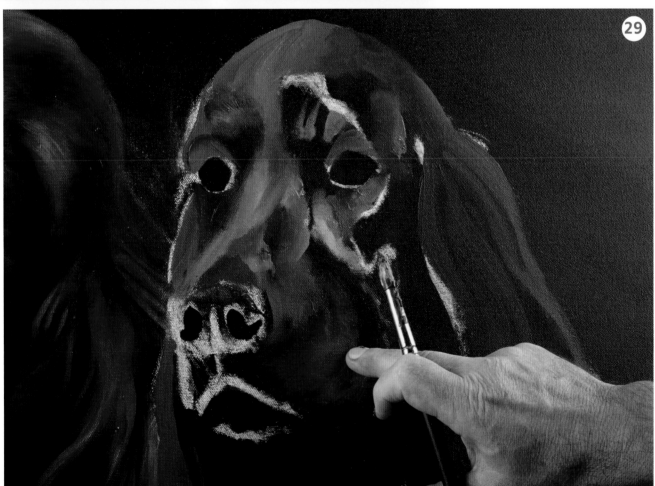

29 Add burnt umber to titanium white and paint this mix on the lighter parts of the dog such as the top of the head and the nose. Mix in burnt sienna and paint this warmer colour on the cheek. Blend in to soften and add shape.

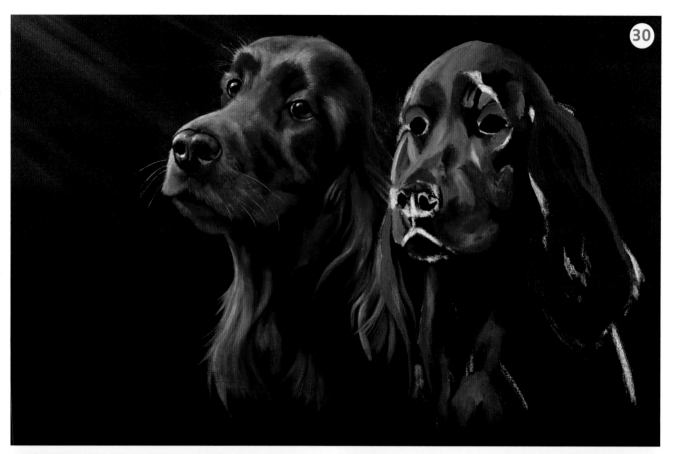

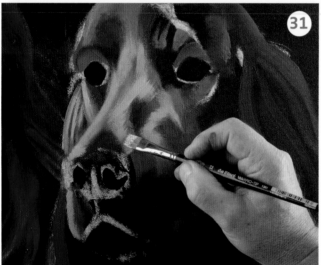

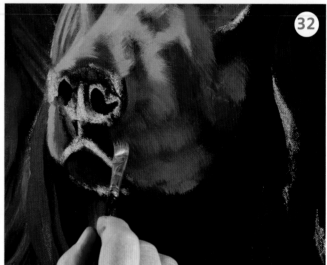

30 Paint a single line of the burnt umber and titanium white mix for the left-hand cheek. Paint some shapes using the same mix to suggest the chest, checking the slanting background light to work out where to place the shadow under the chin.

31 Use a no. 12 rake and titanium white with burnt umber to create the effect of the short hair on the dog's face and head. Blend the light colour into the darker parts of the underpainting with a browner mix.

32 On the right-hand cheek and jowl, change the direction of the brushstrokes with this same mix to create the contours and hairs.

33 Paint the shadowed part of the brows with a darker mix of burnt sienna, burnt umber and titanium white. While this is wet, add more white to the mix and paint on lighter hairs. In this way you create both the underlying form and the appearance of hair.

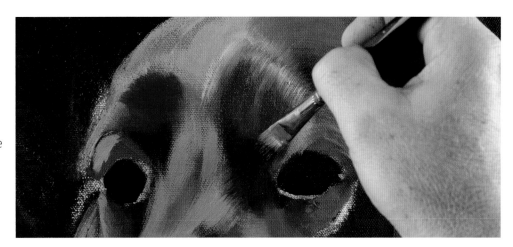

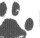 # PAINTING LONG HAIR

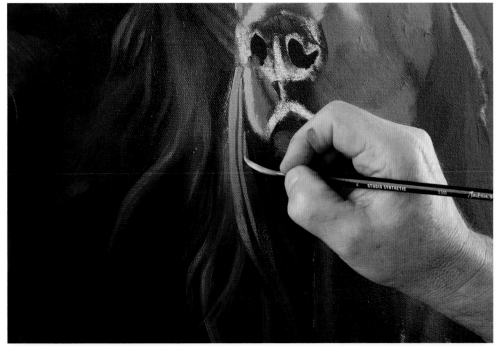

34 Change to a no. 4 rigger to paint the long locks of hair on the left-hand ear with a mix of titanium white and burnt umber. I rest my little finger on the painting to help me create a good, even stroke.

35 Paint the left-hand cheek with three vertical strokes of the same mix, going from light to dark, left to right, then blend with your finger. Now return to the long hair and paint a lighter mix on the left of each previous brushstroke. Blend these lighter strokes in with just water on the brush to make the hair look smooth yet three-dimensional.

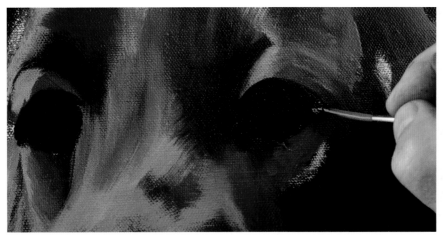

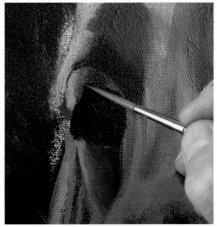

36 When a certain level of detail has been reached, you sometimes need to make adjustments. At this stage, I reshaped Kenzie's eyes with Mars black. Paint burnt umber on the upper eyelids. On the right-hand eye, use thick paint to create a raised ridge suggesting the eyelashes.

37 On the eyelids, paint three tones of burnt umber from light to dark (left to right), then blend with a wet brush to create form.

 ## KENZIE'S NOSE

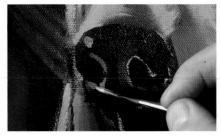

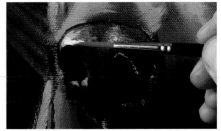

38 Re-establish the nose with ultramarine and Mars black. Add a little titanium white and put in the lighter part on top.

39 Make a lighter mix and paint this around the left-hand nostril where it catches the light, and just above this nostril. Take the paint off the brush and blend in with water.

40 Continue painting on both sides of the central crevice with this tone of blue. Paint titanium white highlights on top of this wet paint and blend. Finally, paint the smallest, sharpest highlights in white and blend the edges with a wet brush to help create the effect of a wet nose.

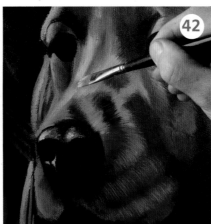

41 Use the no. 12 rake and a light mix of titanium white and burnt umber to paint the fine detail of hair around the mouth.

42 Continue painting lines of hair across the muzzle. Also paint lighter hairs under the right-hand eye and strengthen the light hairs on the upper part of the muzzle catching the light.

 GLAZING AND PAINTING LONG HAIR

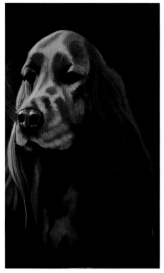

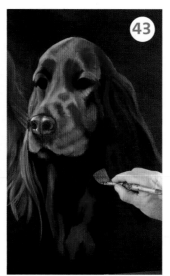

Kenzie with the underpainting finished. It establishes a strong tonal contrast, as Kenzie needs to come further forwards than Demelza.

43 Take a 2.5cm (1in) flat brush and glaze over all Kenzie's fur, and her nose, with Winsor & Newton burnt sienna mixed with water to a waxy consistency. Allow to dry.

44 Change to a no. 4 rigger and paint locks of hair with burnt umber. Press harder to make the locks wider and graduate to thin at the ends. Blend the edges of the locks with your finger.

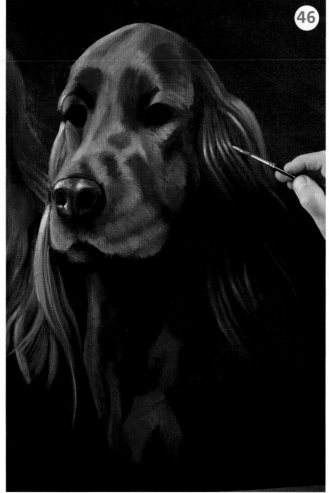

45 Continue, painting finer lines and suggesting the contours of the locks of hair. Add titanium white to the mix for the parts that curve towards us (see inset).

46 Make the mix lighter still to paint the brightest highlights where the hair curves out and catches the light.

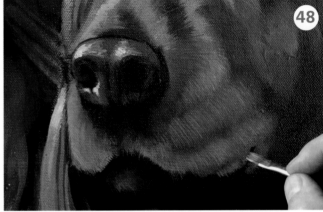

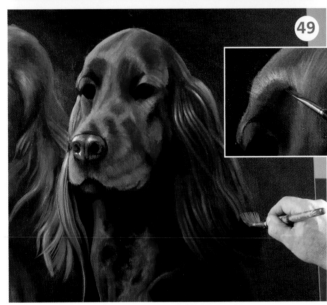

47 Use the side of the no. 4 rigger and a mix of burnt umber, burnt sienna and titanium white to paint a lacework effect suggesting the dog's woolly chest hairs.

48 Paint the mouth with a mix of Mars black and cadmium red deep, then shade underneath with burnt umber. Change to the no. 8 rake and paint hairs hanging over the mouth with titanium white and burnt umber. Allow to dry.

49 Glaze over Kenzie again with burnt sienna mixed with burnt umber and water, using a 2.5cm (1in) flat brush. This should make the dog a bit darker and less orange.

 # KENZIE'S EYES

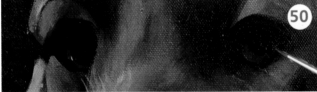

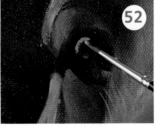

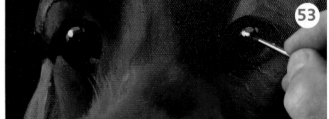

50 Use the no. 0 rigger and burnt umber to paint the irises, reshaping the pupils if needed.

51 Add titanium white and lighten the lower right-hand sides.

52 Mix titanium white with ultramarine to paint a sky reflection in each eye. Wet the brush and lift off some paint to soften.

53 Paint tiny spots of white for highlights in both eyes.

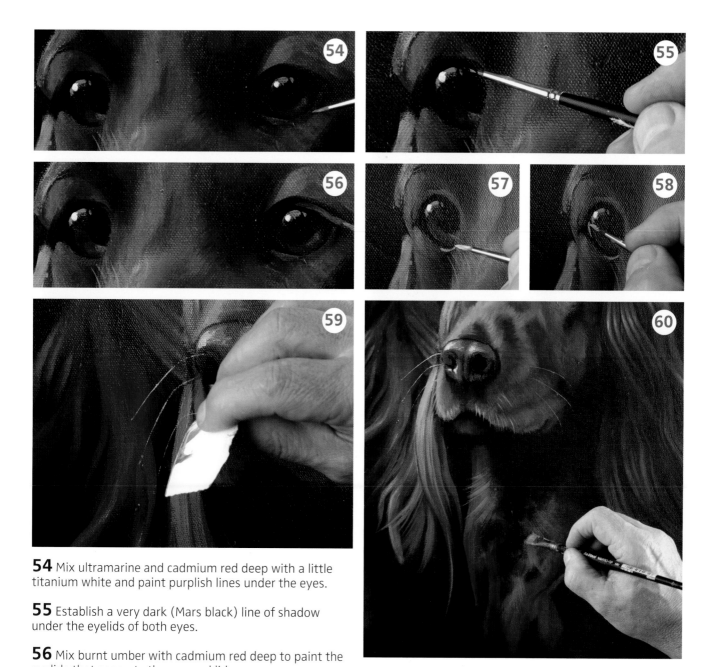

54 Mix ultramarine and cadmium red deep with a little titanium white and paint purplish lines under the eyes.

55 Establish a very dark (Mars black) line of shadow under the eyelids of both eyes.

56 Mix burnt umber with cadmium red deep to paint the eyelids that separate the eye and lid areas.

57 Lighten the purplish lines under the eyes with a mix of titanium white, ultramarine and cadmium red deep.

58 Use a redder mix of the same colours to paint the whites of the eyes.

59 Print on eyebrows and whiskers with titanium white and burnt umber on the edge of a piece of card.

60 Finally, take the no. 8 rake and use the same mix to paint long hairs on the dog's chest.

Overleaf

The finished painting. With this underpainting and glazing method, you can build up colour and detail until you are satisfied with the result. The underpainting allows you to focus on tonal change without worrying about colour, while the glazing binds all the details of the underpainting into one colourful expression. Since you are working with transparent paints, your final image will change with the light from its environment. If you miss some tonal details, apply another layer of underpainting on top and then glaze again. Paint details such as highlights, whiskers and small hairs in their final colour, without glazing, and they will stand out from the rest.

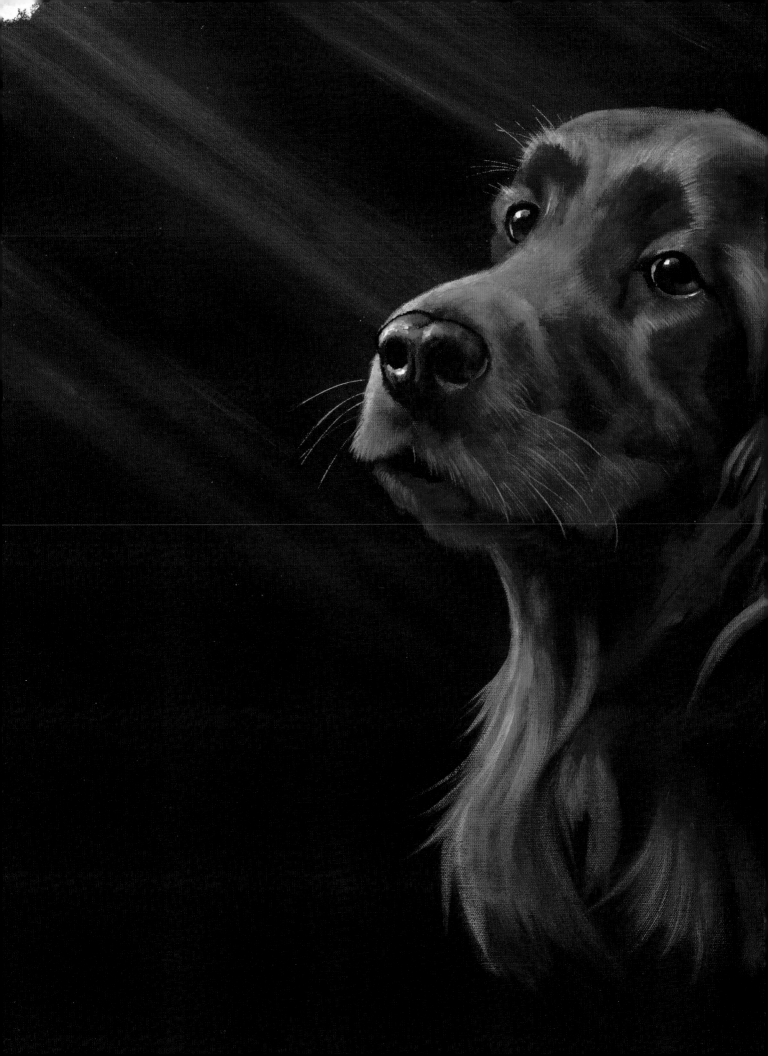

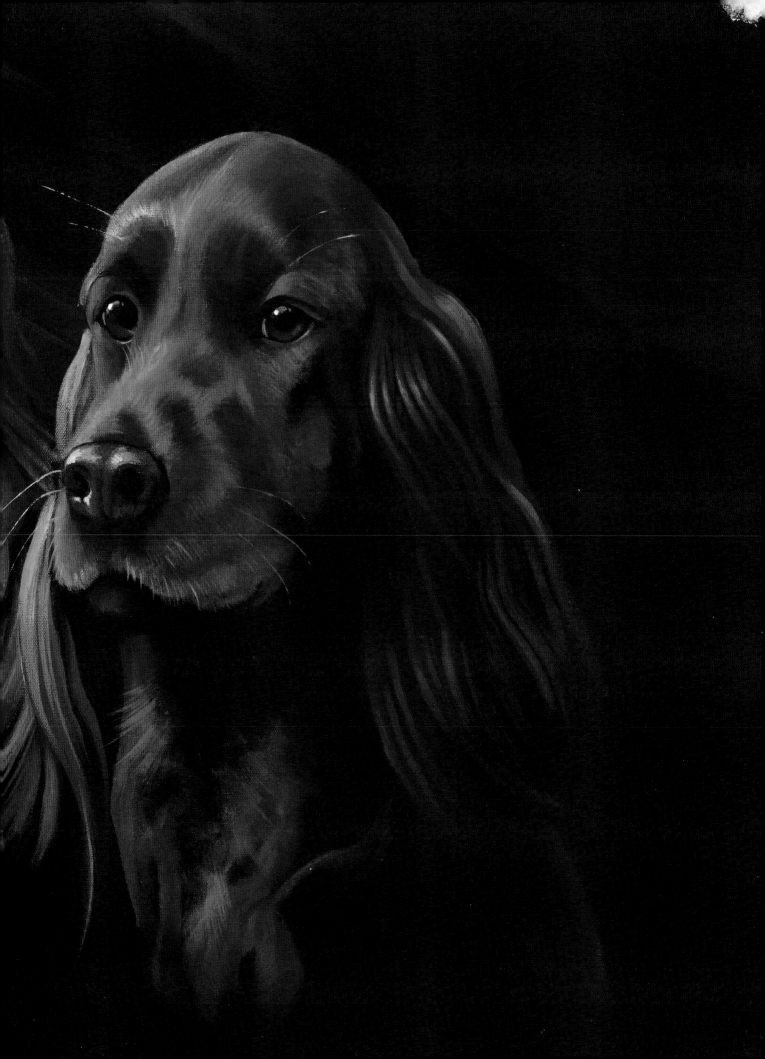

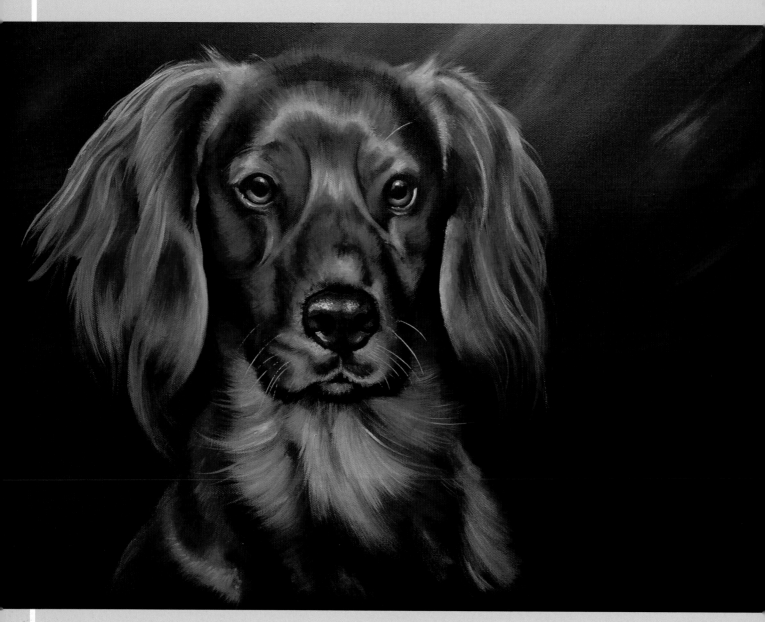

KOBI – WORKING COCKER SPANIEL
61 x 45.7cm (24 x 18in)

The white flash of hair on Kobi's chest is best created by a rake brush.

THE BRITISH SET
91.4 x 61cm (36 x 24in)

This painting is a summary of the best bits from twenty different Setters I painted for different owners in one year. In my opinion (I am generalizing, so apologies to those who own these dogs), Gordon Setters like the one on the left are aloof, some might say arrogant, the Irish or Red Setter is mad while the English Setter is placid or even vacant – the lights are on but no one's home! These views explain why I have painted them the way I have.

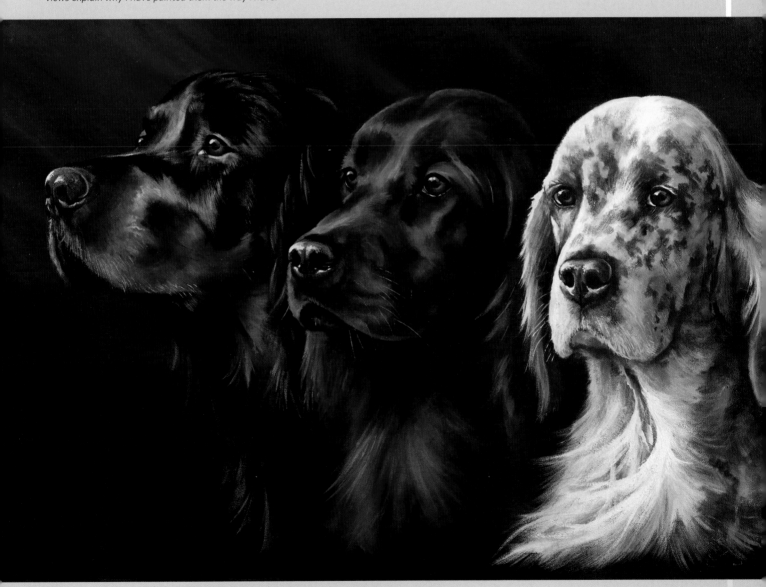

THE DOG PORTRAIT BUSINESS

If you want your creative gift to earn you a living, you need to understand a few things about running your own business. Assuming you have done some dog portraits, you now have to find who you can sell them to.

First, find out what your potential customer wants. Ask your friends and family whether they are interested in commissioning you to paint a portrait of their pet. Ask what type of painting they would want: what size, what background and what they would be willing to pay for it. You will uncover a mine of information, and you might get some orders too!

Second, find out what other pet portrait artists charge and assess the quality of your work against theirs. Use the feedback of your friends and family as well, and you should be able to set an initial price for your paintings.

Finally, find a local upcoming event, secure yourself a slot and prepare to present your work. Make sure your paintings are clearly visible and be available to engage with the public to find out the level of their interest. Ask a friend to assist you so that you can speak to more people and take comfort breaks!

Make sure that you get the contact details of potential customers, and that they get yours. I display my contact details on an A5 leaflet showing a variety of my work. If a potential customer asks for a commission price at a show, I briefly discuss canvas sizes and prices with them. I ask for their phone number and email address, and email the options to them later. After a discussion about the delivery timescale and cost, I work out a date when I can go to meet and photograph the dog(s), and then I ask for a 10 per cent deposit to establish the contract.

Be ready to adapt the paintings you produce if feedback from friends, family and the local public suggests that this would widen their appeal. You need to produce what is actually required if you are to make a success of the business.

The above process creates a market-driven price. However, if you wish to make a living from your work, you need to address the issue of price more scientifically. Assess your overall forecast cost of living, e.g. mortgage, food, car and so on. If you are used to household budgets then this should not be a problem. Work out how many paintings of a certain size you can reasonably produce and deliver in a year and then divide one by the other. To that add an assessed cost of the materials required to produce each painting.

A satisfied customer will recommend you to others and will often come back for more portraits.

Take into account the cost of canvas, paints, hanging materials, postage and packing. You probably already have brushes, an easel and water containers, so there is no need to include these. Your resulting cost will be the average price you need to charge. There are circumstances which might allow you to charge a premium for a special requirement, or there might be features of an order which will allow you to give a discount.

If your price after these calculations is too expensive, you will get no orders. Think outside the box in order to reduce the pressure on your commission price. What other offerings could you provide which will generate income? As well as paintings, I produce prints and cards, do demonstrations and workshops and write books. This additional income allows me to discount my commission prices.

Another major thing to consider as you set up your business is cash flow. Many fledgling businesses flounder because of cash-flow problems, so it is worthwhile converting your pricing assumptions into a cash-flow forecast. Work out when you expect to get orders and deposits, then final payments, and when you will incur costs. This will show when you might expect problems in your business, when you need orders and when you need to attract new customers.

As your business grows, there will be more opportunities to market your work, which obviously involve further costs. I now have a regular stand at Crufts, the world's largest dog show. Shown below is the 'night sheet' I use at all major shows. This is a lockable cover across the front of my exhibition stand to protect the paintings. It allows me to show my work (and those all-important contact details) to the public before the event opens and after it closes, when a lot of people are around. High-profile marketing like this increases my costs and I have to adjust my prices accordingly.

There is nothing more satisfying than making a living from your creative gift, but be aware that the above is only a snapshot of the type of planning you need to do before you launch yourself full time. If you would like a more in-depth guide to the business process, contact me via my website at www.davewhite.org.uk or email me at theartistdavewhite@gmail.com and request Dave's Business Process Guide.

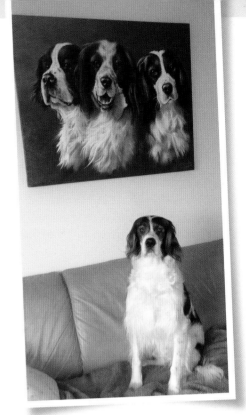

However you run your dog painting business, there is no substitute for a happy customer! Here is Rico in front of the portrait of Harry, Thane and Rico shown on page 49.

Below, left: my stand at Crufts – the world's largest dog show.
Below, right: the night sheet that covers my stand.

137

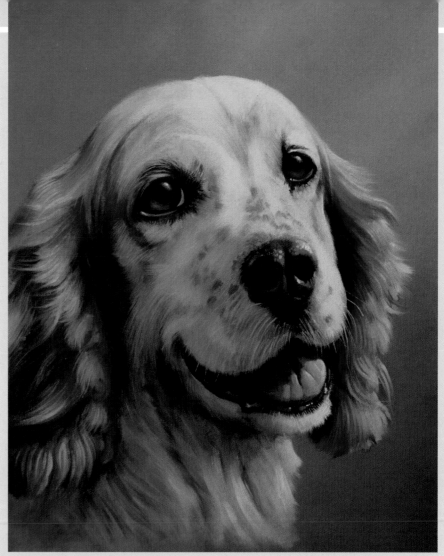

LARRY – COCKER SPANIEL
61 x 45.7cm (24 x 18in)

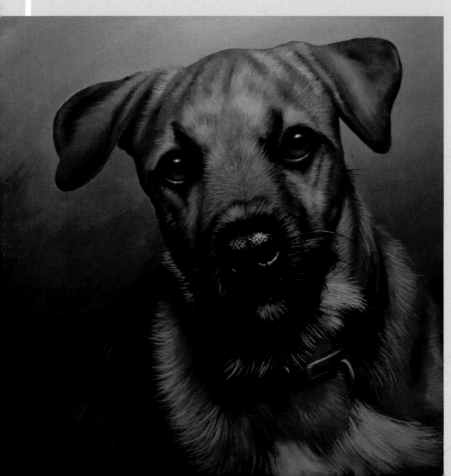

BOW – BORDER CROSS
50.8 x 50.8cm (20 x 20in)

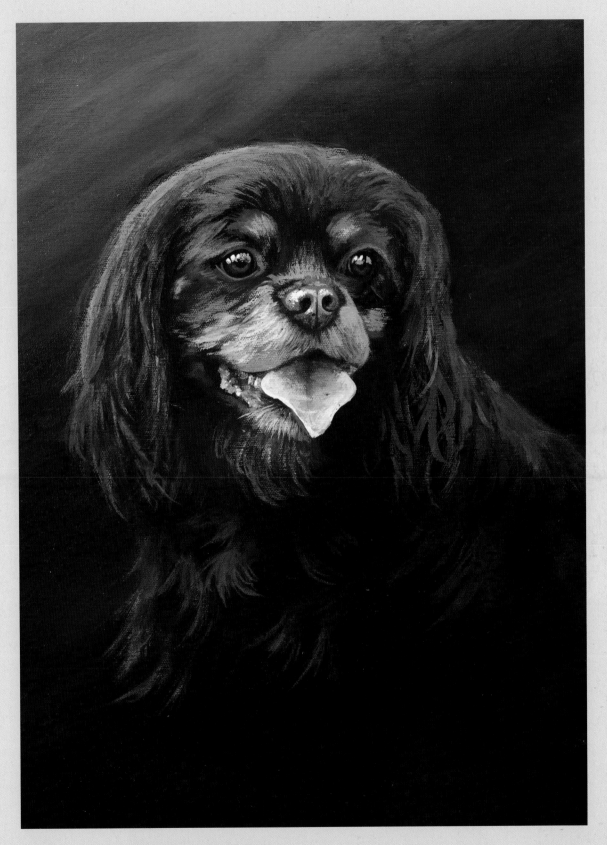

FLINTY – BLACK & TAN CAVALIER SPANIEL
61 x 45.7cm (24 x 18in)

This was my second ever dog painting. It had to be good because Flinty was our dog and the painting was for my wife's birthday. Flinty's portrait goes with me to most shows!

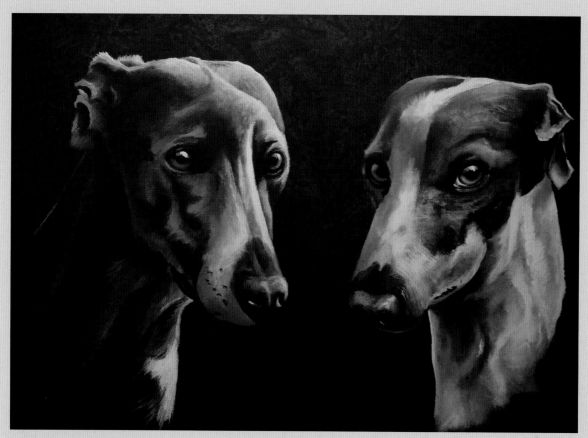

GREY AND YT – WHIPPETS
50.8 x 40.6cm (20 x 16in)

*This was painted for a surprise
birthday present.*

FRECKLES – ENGLISH
SPRINGER SPANIEL
61 x 45.7cm (24 x 18in)

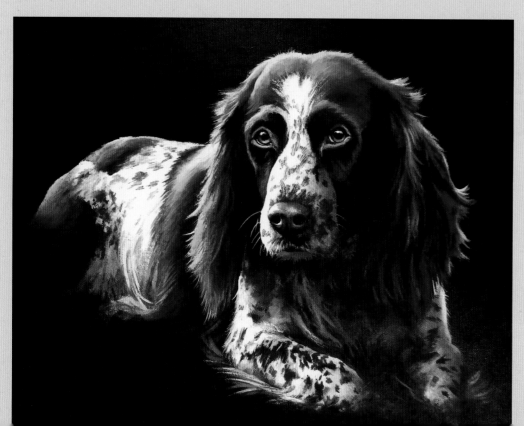

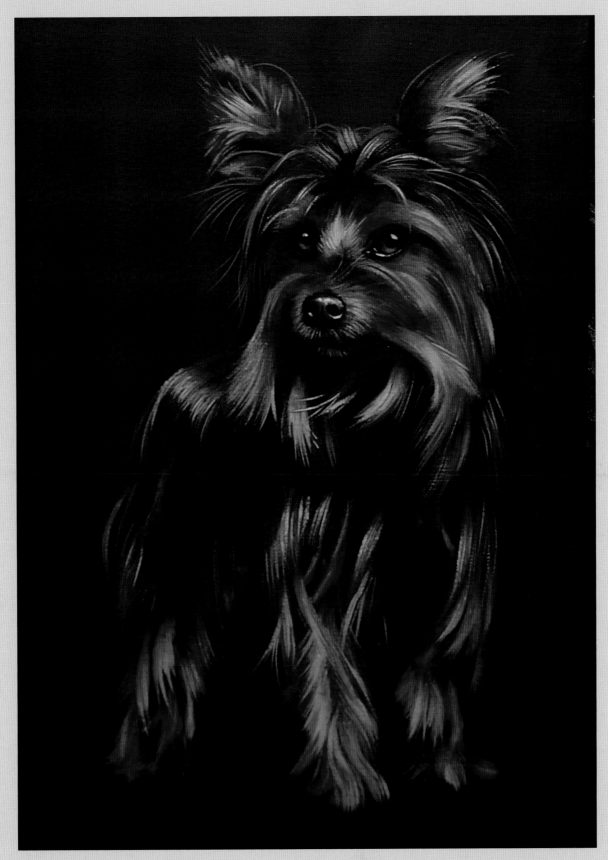

HOLLY – YORKSHIRE TERRIER
50.8 x 40.6cm (20 x 16cm)

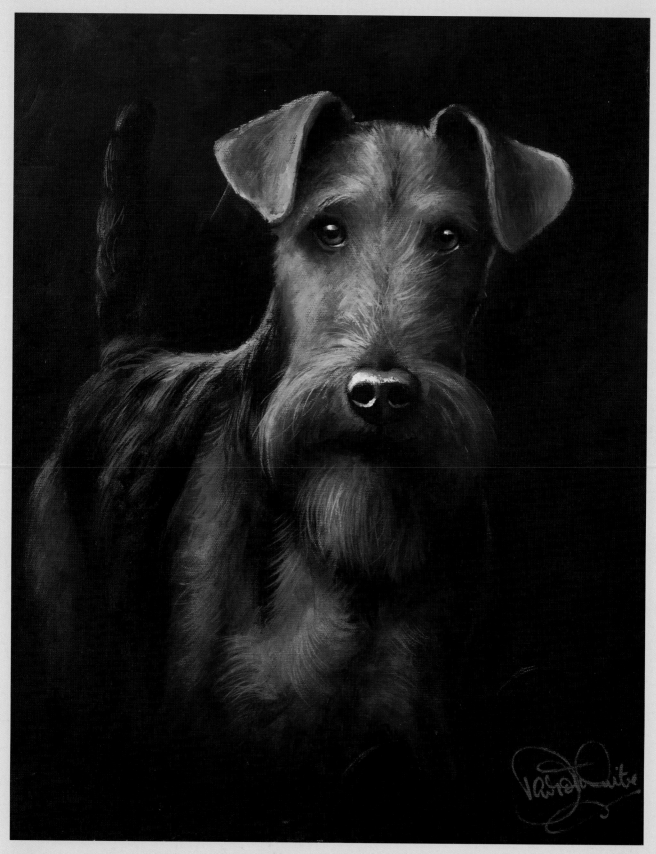

RUPERT – WELSH TERRIER
50.8 x 40.6cm (20 x 16cm)

INDEX

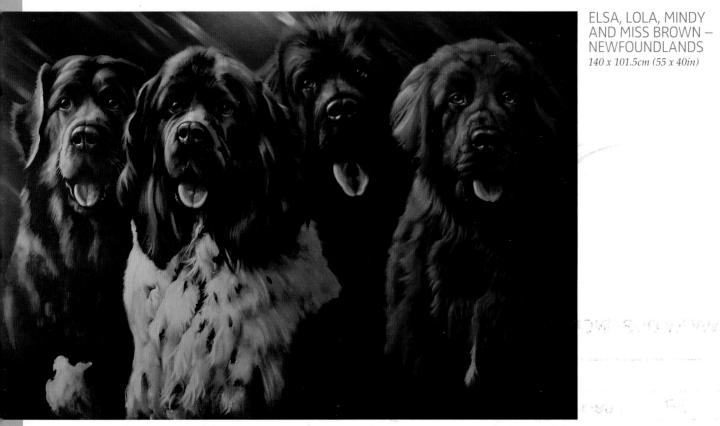

ELSA, LOLA, MINDY
AND MISS BROWN –
NEWFOUNDLANDS
140 x 101.5cm (55 x 40in)